FRANÇOIS-XAVIER DELMAS

IN SEARCH OF TEA

Discovery and knowledge

ABRAMS / NEW YORK

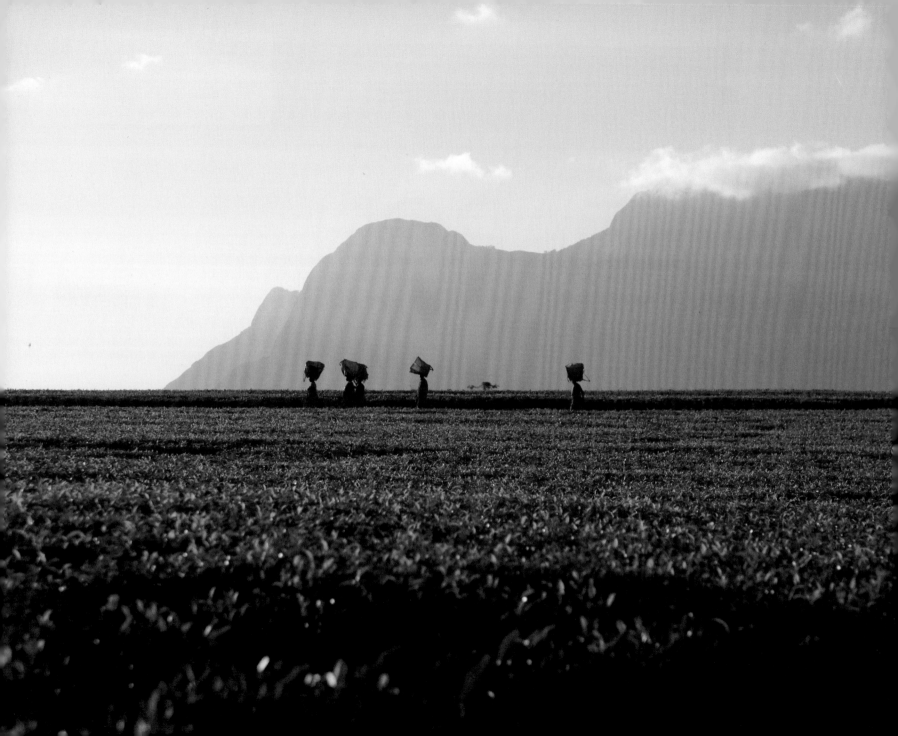

— QUEST 7

— PORTRAITS 63

— GROWING 77

— HARVESTING 121

— PROCESSING 145

— TASTING 169

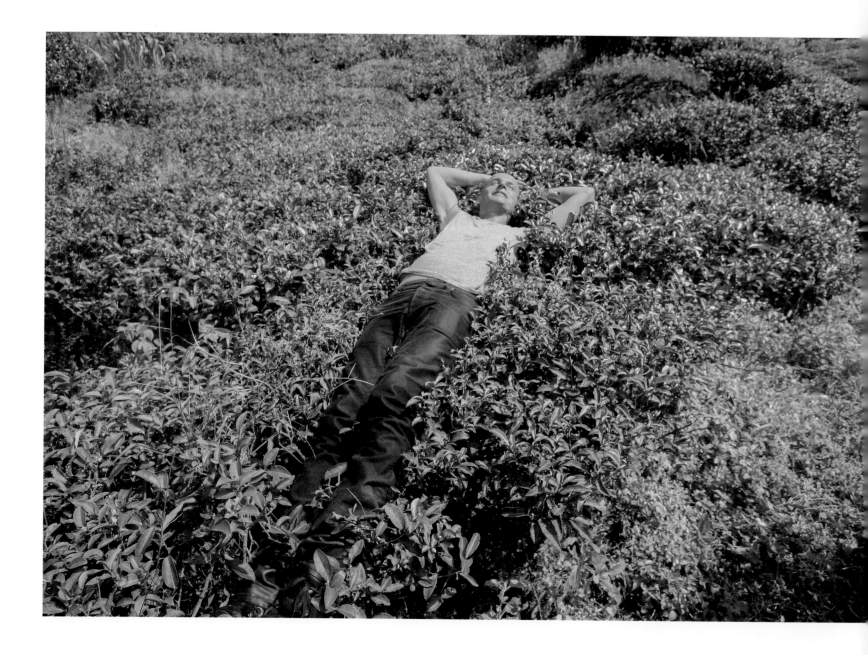

A LONG-HELD DREAM

For a long time, I dreamt of a profession that would take me to faraway places and allow me to meet people from different backgrounds and cultures, people who don't speak my language, who don't have the same experiences as me.

I found tea by chance. By accident. I didn't know anything about it. I founded Palais des Thés and my work became a passion. I gave my job a name: tea researcher. A passion for life. At the same time, happily, our customers were making Palais des Thés a success.

This profession of tea researcher didn't exist before. I could have just stayed behind the counter in my tea shop. Talking to customers, listening to them and helping them is hugely rewarding in itself. But I wanted to go further, to find out more, to discover where these tea leaves came from. First, I learnt to taste, to recognize flavors and aromas. Then I learnt new languages. I was hungry for knowledge, to explore the unknown world of growing tea and the whole culture around it. I packed my bag and set out to meet farmers, growers, traders, pickers, and planters. With each trip I got more and more involved. I sought out the people who live in the mountains where tea is grown. I found them in the fields, in the village square, in front of the factory. I sat with them. I stayed. I listened, and listened some more. I noted down everything.

That's why, thirty-five years later, this job is so fulfilling. What appealed to me in journalism, which was my early dream, I've now found in my work as a tea researcher.

I wanted to pass all this on, to pass on my knowledge to those who work with me, to pass on my knowledge to our customers. To pass it on through our Tea School and through my blog, discoveringtea.com, from which the texts and photos of this book have been taken, and which is celebrating its tenth anniversary this year.

I came to photography later. In the early days of Palais des Thés I'd travel around Asia without a camera. I returned from my trips with the landscapes etched in my memory, but with no images to share. In those days I thought that you had to choose between looking and taking photos, one or the other. Today I know that's not true. In photography I found the same thing I enjoy about tea: slowness. Taking my time. Waiting for the right light. Watching faces for an expression, an emotion.

I hope you enjoy your travels.

FRANÇOIS-XAVIER DELMAS

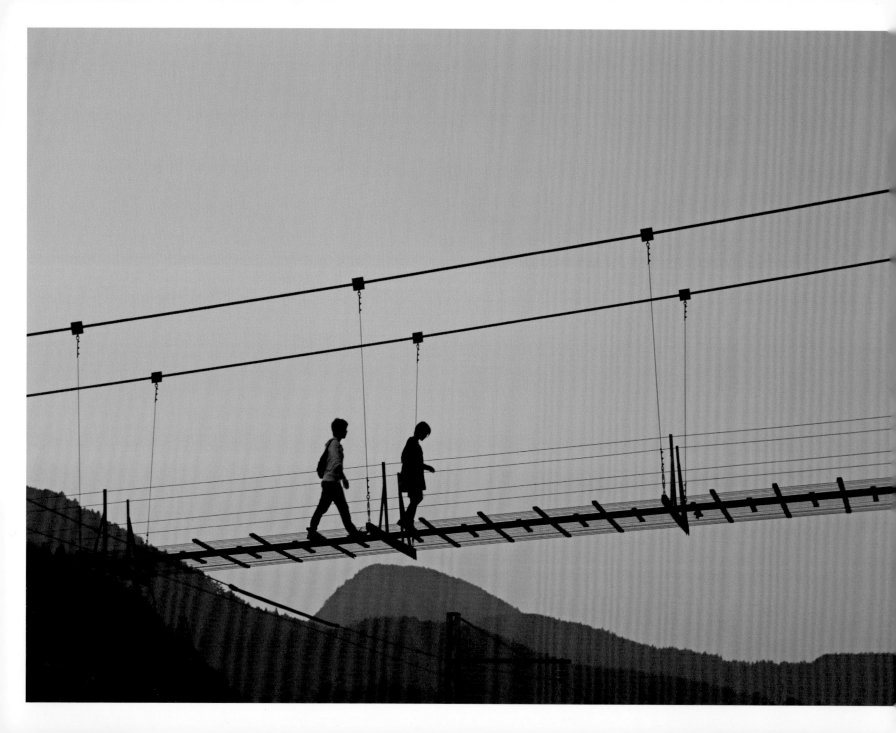

— QUEST

WHAT MAKES OUR WORK SO SPECIAL?
Sri Lanka • 6 December 2019

To give someone who doesn't know about tea the desire to explore it, to lead customers on a journey of discovery through single-origin teas, growing regions, rare and premium teas... that's what makes our work so special. The essence of Palais des Thés is captured in the way we support our customers. What motivates us is to ensure everyone receives a warm and friendly welcome, to offer an incredible choice of teas and attention to quality, to convey our impressions to you, our emotions and expertise. In a word, what motivates us is our passion.

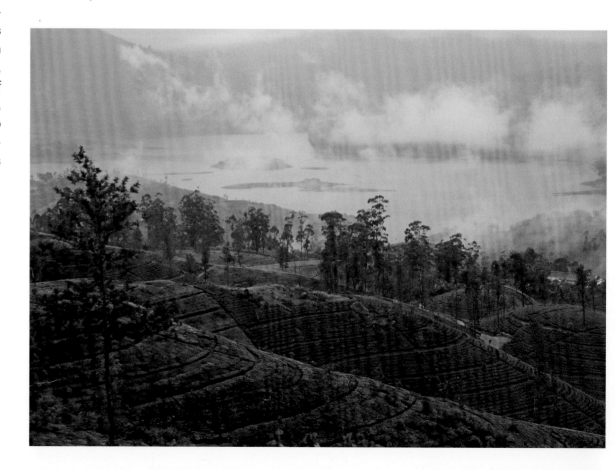

YOU CAN'T RELY ON A NAME

China • 31 May 2019

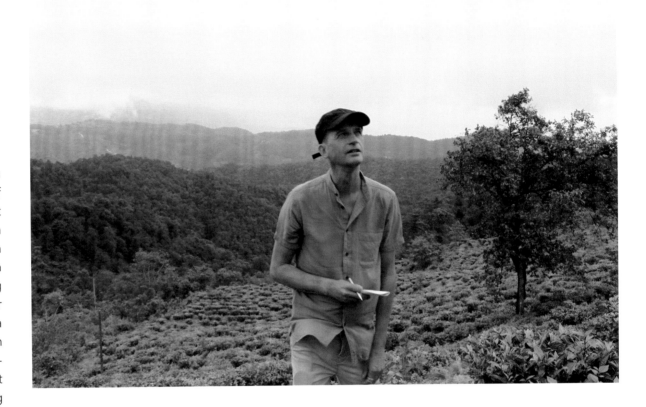

Tea can be complicated in that you cannot rely on a name as a gauge of quality, for the simple reason that tea grows in regions which often experience significant variations in weather. This results in variations in quality. One example is that during the monsoon, it rains nonstop for weeks on end, so obviously the tea isn't good. A prestigious plantation that sometimes produces remarkable teas in the best seasons isn't capable of doing the same during the rainy months. A prestigious garden can also produce bad teas. This means it's important for a tea researcher like me to taste every tea before buying, and to never rely on a name. It's also important for the customer to be well informed and guided by skilled sales advisers.

A HAND

India • 17 January 2020

There are artisan teas, and there are industrial teas. The same is true for many of the products we consume. If we had to choose something that symbolizes the work of the artisan, we could talk about their craftsmanship, or we could talk quite simply of their hands. Artisanal work involves the hands. To produce a fine tea, to pick the best leaves or to take cuttings, hands play an essential role. What if we consumed better quality, but less? Every time we bought an object or item of food, we could ask ourselves if hands played a part in making it.

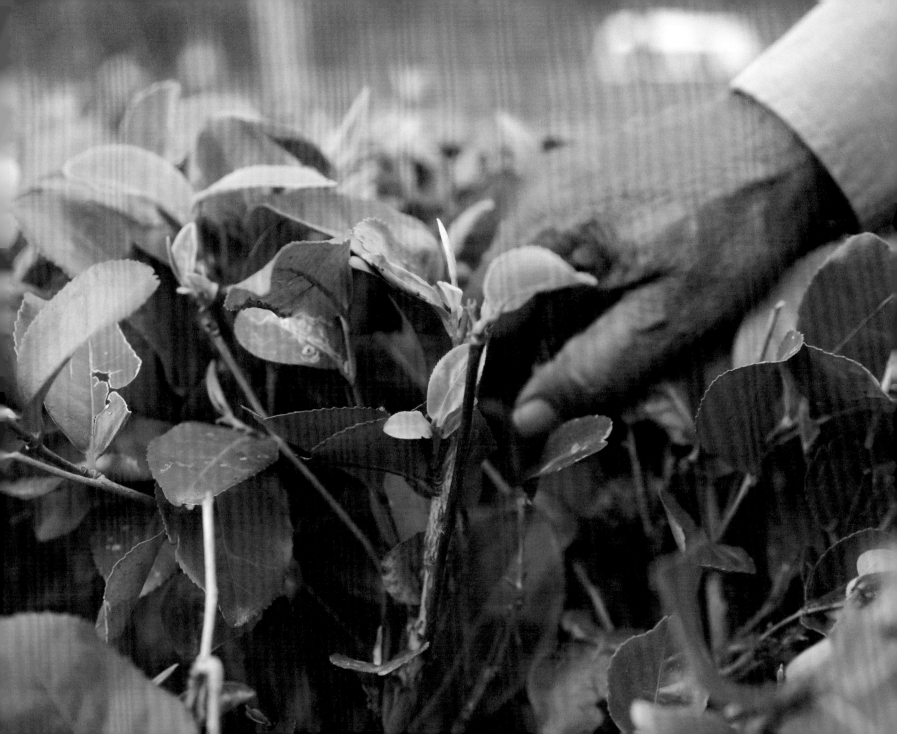

This is the type of house I stay in when I'm in Darjeeling. It's a planter's bungalow, typical of the region. There's one on each tea plantation, where the planter and his family live. When I wake up, I sip my early morning tea, served in bed as is the tradition, and wait for the sun's rays to warm the ground and bathe the flowerbeds in light.

TEA PLANTER'S BUNGALOW IN TEESTA VALLEY
India • 4 March 2011

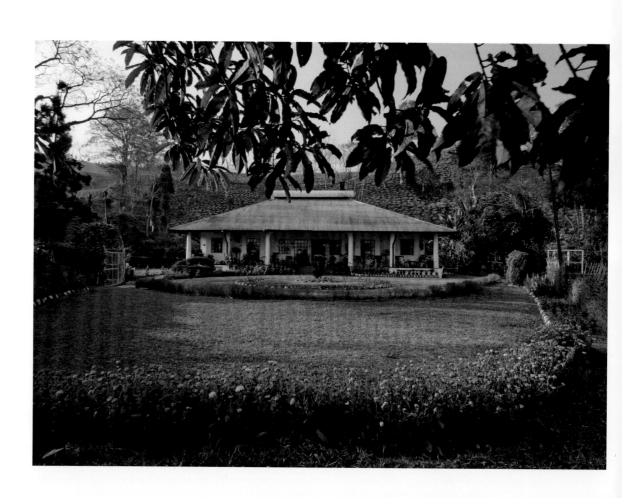

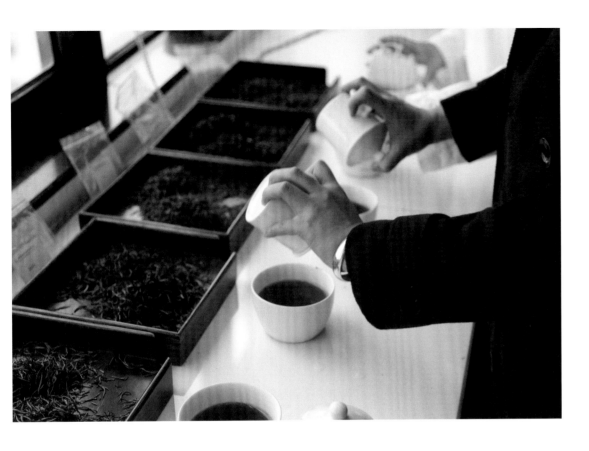

ABOUT
PREMIUM TEAS
China • 29 November 2019

One question often crops up when I meet customers: the way we source our premium teas. With the growing number of Palais des Thés stores, people want to know if I can always find enough fine teas without compromising on quality. The answer is simple. Right now, I must taste about a hundred teas on average to identify one or two premium teas. But it's not a problem to try more and choose more. However, I can't alter the size of the batches. If a farmer has produced one hundred kilos of an exceptional tea, I can't ask him to send me two hundred kilos without affecting the quality. But I have no problem finding other farmers who produce exceptional teas. So to sum up, it's not difficult to source other premium teas, but the size of the batches is limited, meaning you won't find the same choices of premium teas in our different Palais des Thés stores on any given day.

RITES AND BELIEFS

Nepal • 22 December 2017

Divinities differ from country to country, and while some people are celebrating Christmas, on other continents they worship Shiva, or pray to Allah, or follow the words of Buddha. Through my work I'm lucky to come across people from different cultures and religions, and I love this variety. Happily, we don't all think the same way yet; our customs and rituals differ, and we speak different languages depending on where we're born. I hope this continues as long as the world exists. It makes travel more interesting. Some people follow a religion, others don't, though the latter are rare in the parts of Asia and Africa that I visit. Among them, I find a multitude of different rites. People pray before a wall, from a pulpit, at the foot of a minaret, or around a stupa. They pray to the wind or to fire; they place offerings at the foot of simple statuettes.

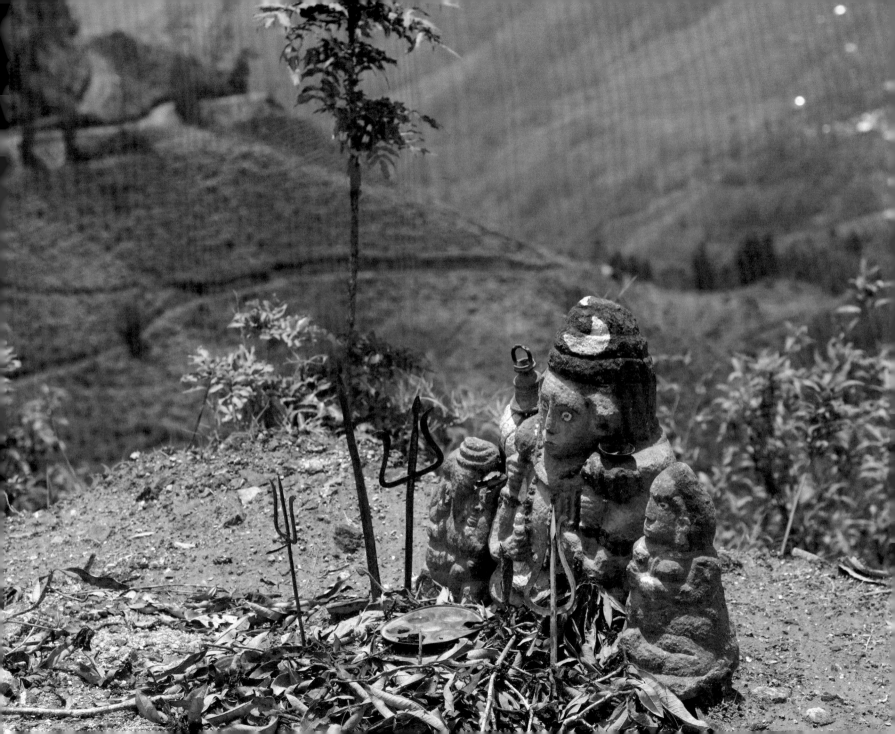

SAFE PASSAGE

China • 3 May 2019

I've finished selecting my first-flush Darjeelings: twelve premium teas in total. From plantations such as Puttabong, Thurbo, Namring Upper, and Highlands, they represent the best of what these mountains have produced during the season. Now I want to tell you about the steps that follow the purchase of a tea of exceptional quality. First, the tea is packed on the plantation, then transported by truck to the nearest airport. From there, it travels to Paris, and on to the Palais des Thés warehouses. A sample of the batch is then sent to the lab for analysis. Once we've received confirmation of its compliance with the SafeTea standards that are the pride of Palais des Thés, it's distributed to our various stores. The journey from plantation to cup takes several weeks and cannot be rushed. It's a mark of quality and safety.

When I travel across some regions of France, I'm alarmed. Where are the hedges? Where are the field margins? When I travel around the world, if I come across a tea plantation that extends as far as the eye can see without so much as a tree, hedgerow or field margin left to nature, I run a mile. I can be sure that I won't find clean teas there, grown in conditions that respect nature. To produce clean teas without the use of pesticides, you need to work with nature. You need ladybugs to attack other insects, you need birds to eat the insects, you need earthworms to aerate the soil. You sometimes need cows, to mix their manure with green waste to feed the worms and enrich the soil. All these creatures need somewhere to live. Hedges, trees, field margins, even a cowshed. In my job as a tea researcher, which involves seeking out good quality products grown using clean and sustainable farming methods that respect nature, a field containing a single crop covering hundreds of acres is a nightmare scenario. Here, in Poobong in India, is a landscape that offers hope for biodiversity.

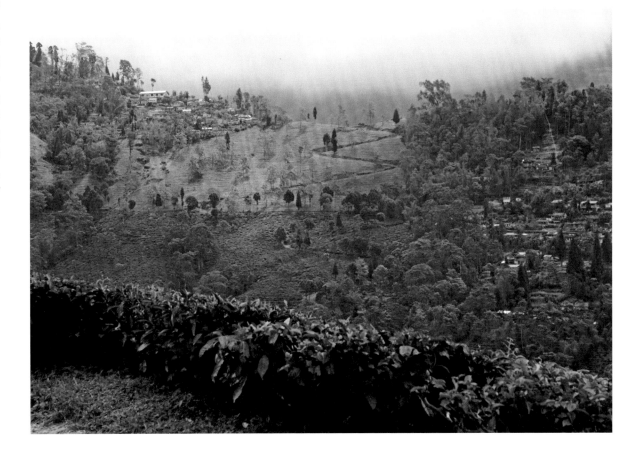

IN FAVOR
OF FAIR PAY

India • 14 September 2018

How much longer will tea be harvested by hand in India, where there is ongoing conflict over employment conditions? The pickers are justified in demanding pay rises, but the plantations are only just profitable, and some are even loss-making. Tea is already sold at a high price without benefiting local populations. Do we risk seeing mechanical harvesting replace manual picking due to a lack of workers? And what will be the consequences on quality? Or are we moving toward plantations being turned into cooperatives so that everyone has a stake in them and can live decently on their wages? These questions have not yet been answered.

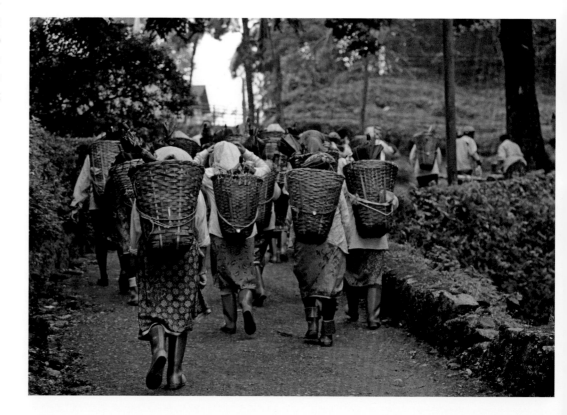

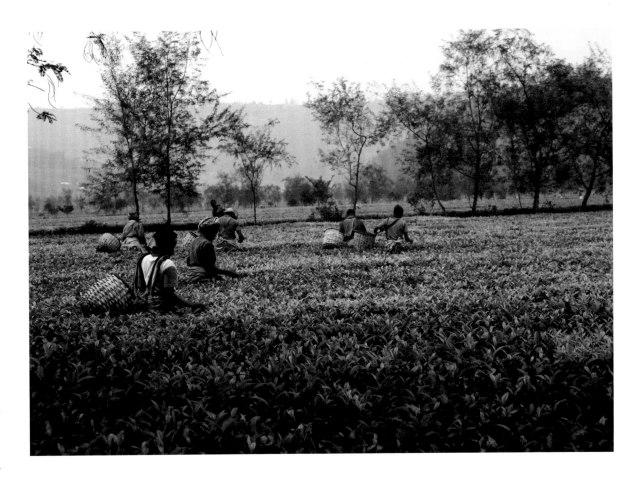

ALWAYS STARTING OVER AGAIN
Rwanda • 19 October 2018

When I'm searching for premium teas, I look at what the farmers and plantations I already know are producing. I also look for new farms, sometimes in new regions, sometimes in new countries. Sourcing premium teas means starting over again every time. When it comes to rare and exceptional teas, there's no guarantee that a reputable producer will be able to make a tea as amazing as the previous year. You must try the teas, blind, so you're not influenced by the prestige of a name or your goodwill toward a farmer. And sometimes you have to pack your bags and set out on an adventure. Rwanda, for example, can produce some very good teas, and is one of the countries I intend to return to soon and explore different plantations.

GETTING AWAY FROM IT ALL
Malawi • 10 August 2018

We all like different kinds of holidays. I like to take a step back—or up. This might mean hiking to reach a mountain peak or walking up a hill, then sitting down and enjoying the view for hours. It can also mean reading, which is another way of "getting away" and taking a step back from everyday life. Or, I like to sit by the sea, cup of tea in hand, and look out across the water. It feels good.

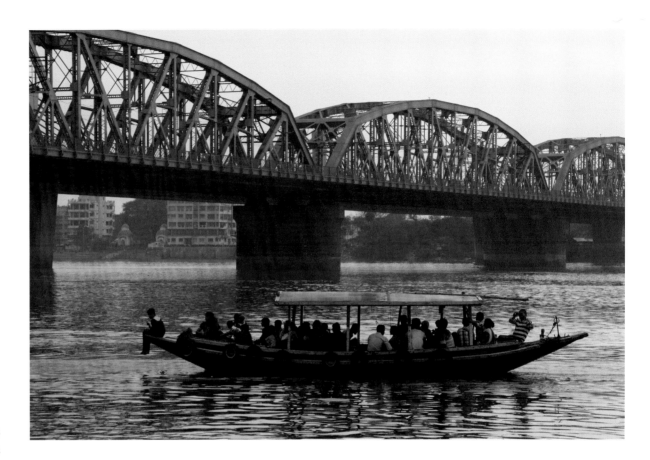

TEA AND JOY
India • 7 September 2018

Kolkata, formerly Calcutta, is known as the "city of joy," but it's also the city of tea. All the producers of Darjeeling and Assam teas have their offices there. Auctions take place in the historical district of BBD Bagh, supplying the lifeblood of a whole economy, and the precious cargoes of tea are dispatched from the city's port.

Kolkata, a sprawling city of ten, fifteen, even twenty million inhabitants—who knows?—extends outwards from the banks of the Hooghly River, a tributary of the Ganges. Its public transport system includes many boats that offer a peaceful crossing, away from the busy traffic.

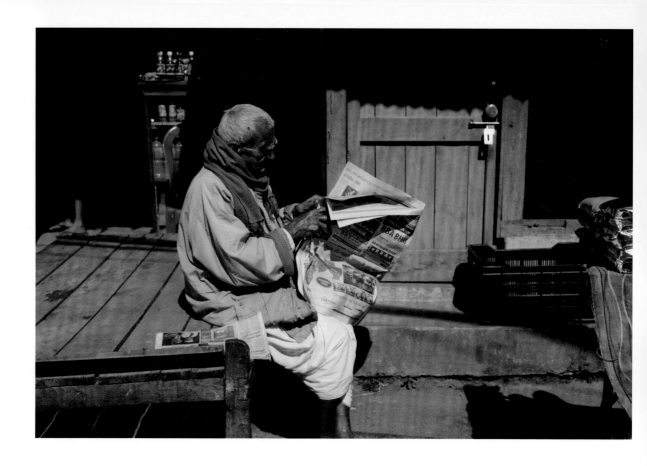

TEA AND PAPER

India • 27 July 2018

Tea and paper don't get on at all well when broken leaves are imprisoned in a cellulose bag and added to a cup with hot water, which we're told is tea. On the other hand, tea and literature are an inseparable couple, and many writers have dipped their pen in the ink of tea. What could be more pleasurable for a reader than to enjoy one's newspaper or novel with a teapot at one's side?

Africa produces enormous quantities of tea—did you know that Kenya is the world's biggest exporter? It's mainly low grade, destined for the production of tea bags. But if you look carefully, you can find some incredible teas in countries such as Kenya, Rwanda, Uganda, and Malawi. Discovering rare teas in Africa, Asia and elsewhere is what my job is all about. It's a job that is constantly changing from one season to the next, from one year to the next. No two harvests are the same. You must taste again and again, season after season, to find the best teas of the moment.

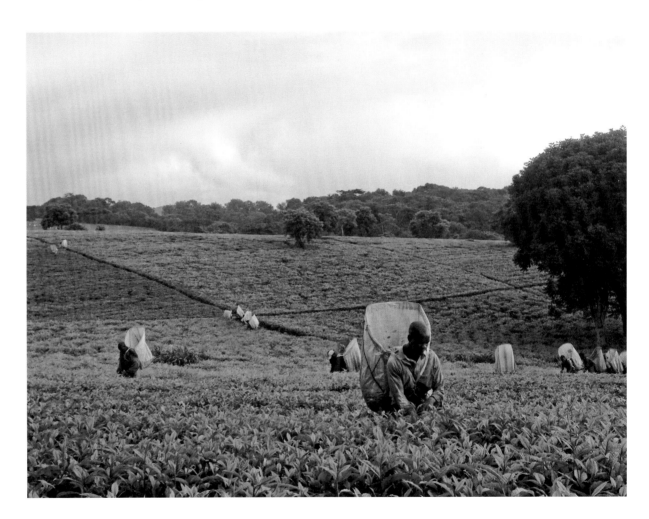

REMEMBER TO
BE HAPPY

Nepal • 1 December 2017

A few days ago, while walking in a remote part of Nepal on a track that winds through hamlets and tea fields, I remembered my first trip to this country a little over ten years ago. I remembered the curfew, the war, the ban on driving at night, the soldiers who were afraid, and made you pull off the road and get out of your vehicle while pointing an automatic weapon at you. I remembered the Maoists who held villagers to ransom, who took their belongings if they couldn't pay their taxes, and sometimes even one of their sons. I remembered stories of executions, a father or mother in tears. I remembered all this pain, and now, on this little path surrounded by glorious nature, I thought that sometimes we forget to be happy, we forget to see the good things. It's easy to spend your life lamenting that everything was so much better before, that everything's going to ruin, when sometimes the world is improving. It's a shame not to think about this, to forget to be happy. So I stopped walking and looked all around me at the incredible landscape in this peaceful country that has put the war behind it. I took my time to appreciate it and to feel thankful. Sometimes the world is beautiful.

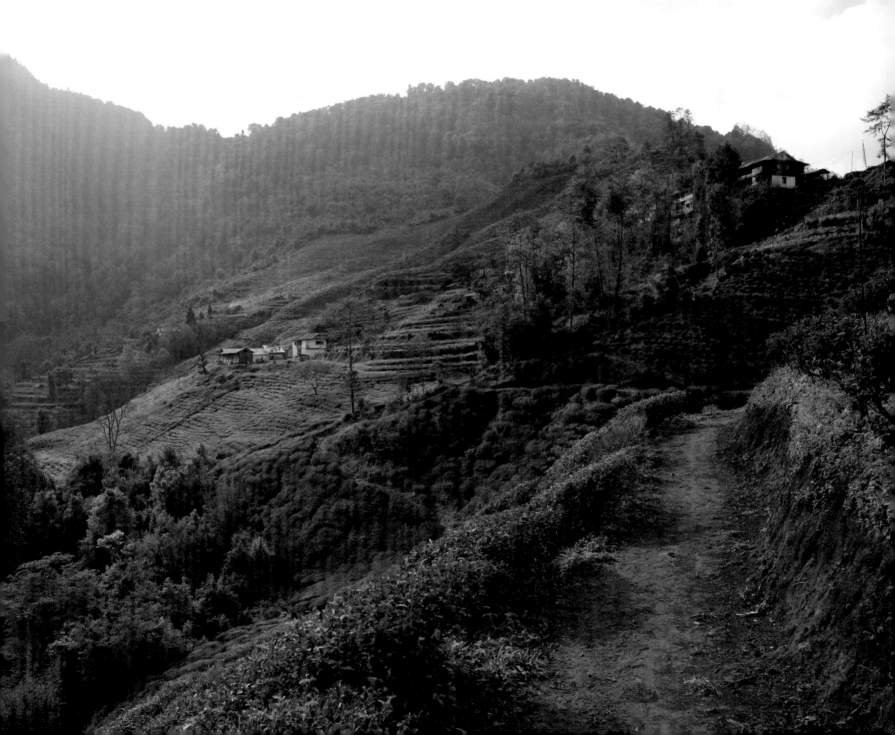

A SCARF FOR A BLESSING

India • 11 March 2016

In India, people sometimes welcome you by placing a silk scarf around your neck and blessing you. At Delmas Bari, I was so saddened to see how dry the soil was that, in front of my hosts, I took the scarf that had just been given to me, and I blessed in my turn. I blessed one of the tea plants on the plantation, in the name of all the others, and I prayed for rain to come.

26

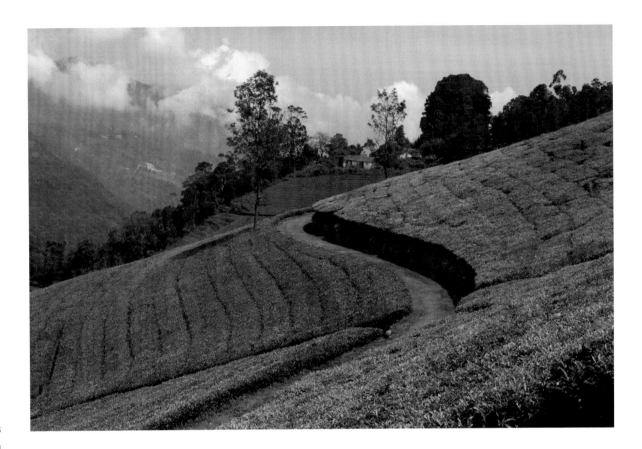

PROGRESSING SLOWLY

India • 8 June 2018

For me, tea is more than a goal, it's a path. I can't imagine ever knowing everything there is to know about tea. A lifetime isn't enough. Tea is a path: what's important to me isn't arriving but progressing. Progressing in my knowledge of the plant, in my knowledge of the art of processing the leaves, progressing on my journey through the tea fields to reach the villages where the communities live. Progressing slowly but surely, in a world where everyone is rushing.

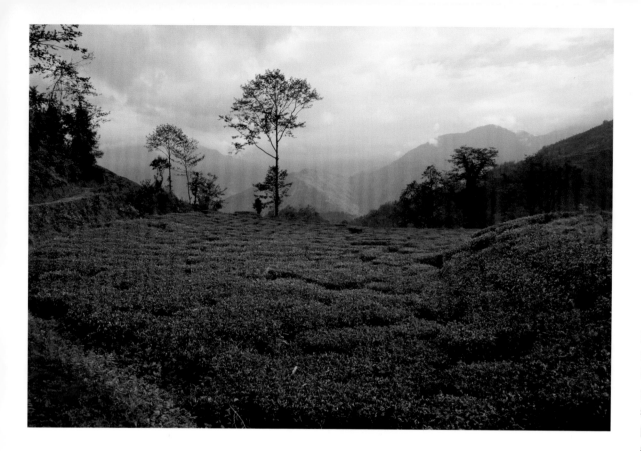

IN SILENCE
Nepal • 15 December 2017

I like silence. I hate it when people make noise for no reason. I don't have a television. I don't see the point of listening to music constantly. I've noticed that many people are afraid of silence. They go around with headphones on, they talk even when no one is listening, their thumb constantly swipes their phone screen. They're filling a void that feels threatening. But what is there to be afraid of? I'm happy with silence. I'm happy surrounded by nature, away from human noise. It's the same with photos. A good photo needs no commentary. No noise. You can just contemplate it.

LESS PLASTIC

Nepal • 22 June 2018

I'm worried about the state of the planet, and the proliferation of plastic is one example of this. We might think of tea plantations as idyllic places high in the mountains, some on steep slopes, far from cities, surrounded by beautiful countryside. All that is true. But tea requires a lot of manpower, and many people live in villages around the plantations. These people buy products that are often packaged in plastic, and this plastic needs disposing of.

On the tea plantations, it's not unusual to see rubbish lying on the ground between rows of plants, simply because people don't think about it and throw away a bag, or a packet of cigarettes or biscuits, in the middle of the field. This waste accumulates. The ground is sometimes littered with it after people have eaten their meal. The best solution I've seen involves holding a litter-picking day, once a year, for all villagers, including children. The atmosphere is good-spirited, it makes people take more responsibility, and at school they talk about the lifetime of the different types of rubbish. A plastic bag lasts for four hundred years!

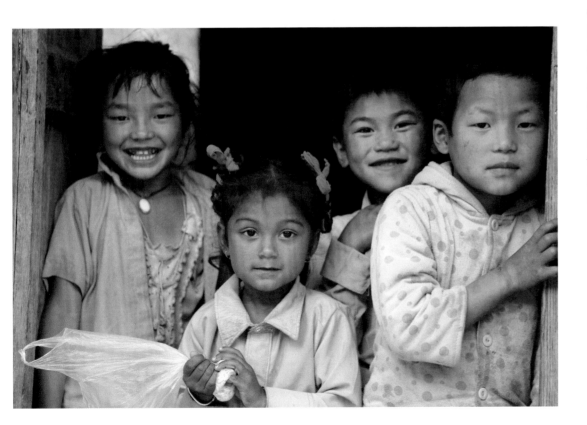

BLUE AND GREEN
India • 25 November 2016

Blue and green are my favorite colors. Blue, because the sea has been very important to me, and the island in Brittany where I spent all my childhood summers taught me a lot about life. The blue that comes and goes with the tides; a blue that turns green then brown when the tide goes out; the blue of the swollen sea; the blue of Brittany's skies (though there are those who love its drizzly rain too).

Blue and then green, the green of tea fields, the green of camellias, a dark green or a yellowish green, depending on the variety. Leaves that are glossy green or matt green, depending on whether you look at them from above or below. The green of the paddy fields that meet the slopes covered with tea plants; the green of the forests, so essential to keeping our climate balanced; the dark green of *Cryptomeria japonica*, that spindly, rather bare tree that I love, found from Kyoto to Darjeeling, with its needles that hold the mist so well; the green of the forest school I attended; the green of the countryside, of my little piece of nature where I'm so happy; the different greens of all the herbs I use to season my food; the green of young shoots; the green of springtime; the green of nature awakening. Green, the symbol of life.

I was incredibly fortunate, when I woke yesterday without knowing exactly where I was, to discover this sublime view from my bed. I'd arrived in Ella late the night before, from Ratnapura, and without the moon I couldn't get a sense of the landscape. I was woken at 5am by the birds singing, as well as the shrill cries of the squirrels, who were celebrating daybreak in their own way. I went out onto the terrace to enjoy the sight, and I stayed there, taking it all in. This mountain is called Little Adam's Peak.

I hadn't been to this beautiful country for a year, and I'm happy to see that in the mountains in the center of the island, a few factories that used to make teas industrially with a rotorvane machine, which is very rough on the leaves, are now at least trying to make teas the orthodox way, a method that's more respectful of the leaves. They are just attempts, I know, but it's a promising sign and it's a pleasure to see that tea planters want to try out new methods and make better teas; that they are curious, and want to improve their quality.

LITTLE ADAM'S PEAK
Sri Lanka • 2 December 2016

31

BRIDGES THAT
CONNECT PEOPLE

Myanmar • 6 January 2017

I love bridges, great and small. I love anything that spans a chasm and connects people. Some people build walls, others build bridges. There are people who shut themselves off, who want to surround themselves with barriers. Others throw down ropes or ladders into the void; they aren't put off by precipices or obstacles or difficulties of any kind. They overcome them. Some people are fearful, some people are trusting. I hope you have a year full of bridges, challenges, daring. I hope you're able to follow your heart.

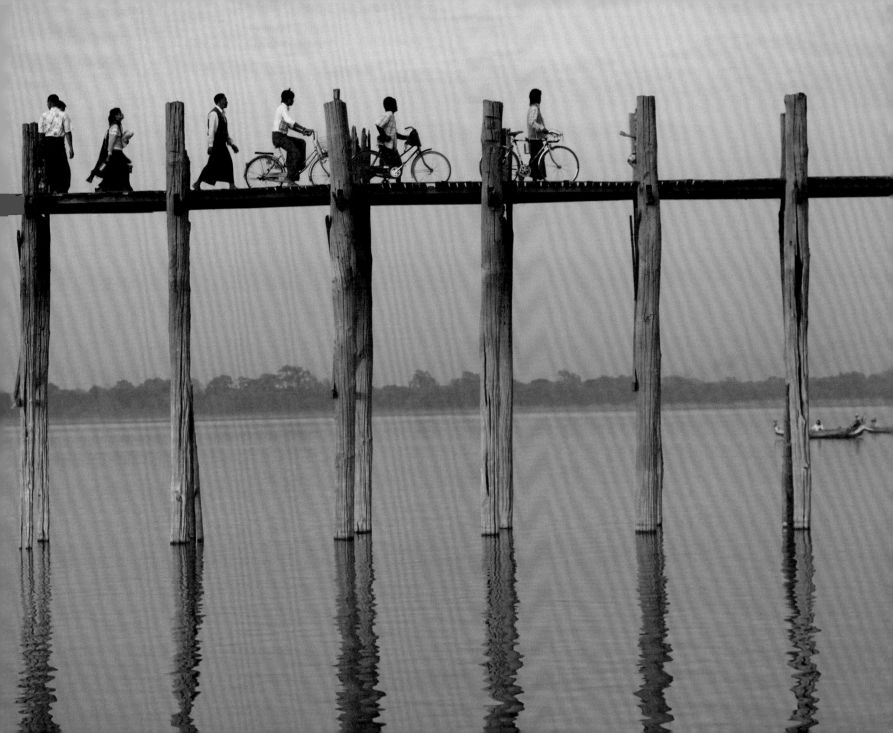

A MOUNTAIN-TOP HARVEST

China • 9 September 2016

It's not easy to reach the wild tea plants growing on the border between China and Vietnam, especially in the hot season. The stifling, muggy air slows you down, and the leeches that infest the region take advantage of this and cling on. You walk beneath a high sun. The humidity is palpable. But once you're out of the jungle, after a good three hours of walking, you find yourself high up, among the incredible tea plants that have been left to grow like trees, and you can take in this beautiful sight, especially if you're lucky enough to arrive just as the leaves are being picked.

34

When I set out to visit Sri Lankan plantations, I stop off first in Colombo to taste the teas being sold at auction in the following days. It gives me a good idea of the quality being produced by the different gardens. Each of these boxes contains a few tea leaves and is marked with the batch number.

TEA AUCTIONS

Sri Lanka • 11 September 2015

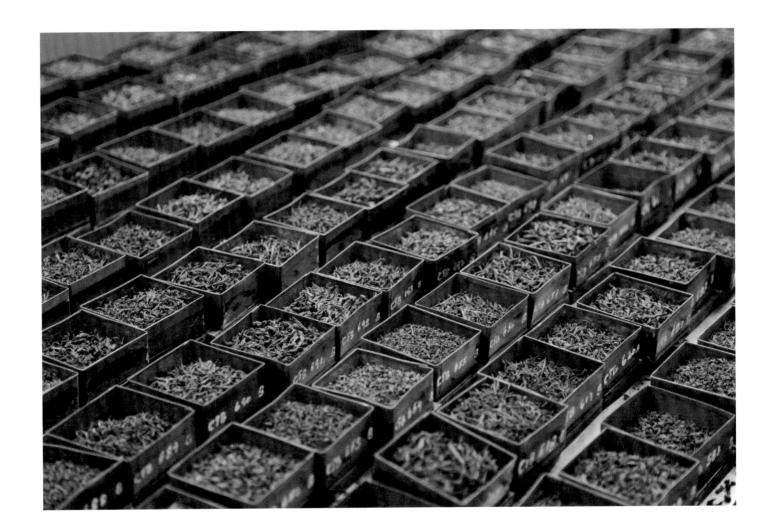

IN PRAISE
OF SHADOWS

Japan • 20 January 2017

If you want to get to know Japan, I recommend, as well as *Empire of Signs* by Roland Barthes, *In Praise of Shadows* by Junichiro Tanizaki. I brought it with me to read here, in Japan. It talks about the relationship we have with light in the West and East: diffuse light versus direct light; a fondness for shiny things compared with a preference for matt. In the West, we want total light; elsewhere, like Japan, more of a half-light. Tanizaki also talks about lacquerware, darkness, and Japanese cuisine, which goes with shade. He has this to say about theater, though I think it also applies to the food and the dishes in which it's served: "In the glare of harsh light, its aesthetic virtues would disappear in a flash." He also says this, which I really like: "We Orientals make things beautiful by creating shadows in places that in themselves are insignificant."

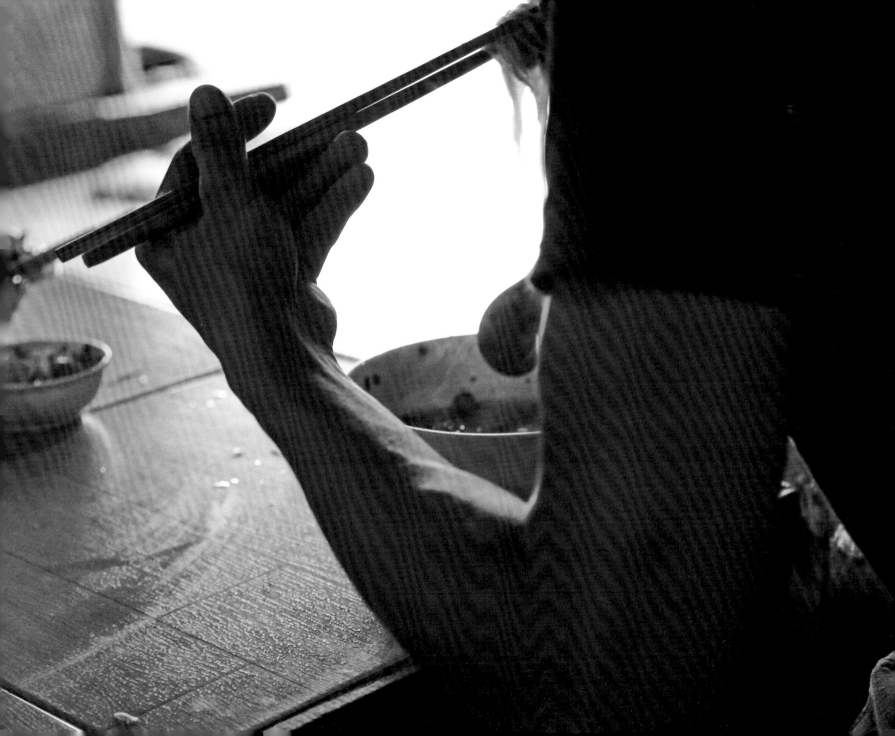

TEAS THAT ARE GOOD FOR THE HEALTH

India • 11 May 2018

My work has changed a lot in the past thirty years. In the early days, I would select teas, then we had to get them here as quickly as possible if they were premium teas—we called them "rare and ephemeral." I would visit every farm, of course, but that's where the work ended.

Today, our demands—and I'm talking about our own demands just as much as our customers'—in terms of health, food safety, and environmental respect, are so much greater. It's no longer enough to find teas that are remarkable for their flavor qualities. They must also meet strict standards. Happily, European standards are the strictest in the world. Food safety is better. Flavor and health have become inseparable, for which I'm grateful. It's up to me to make sure you can taste these rare teas as soon after harvest as possible.

AN ISOLATED FARM
Nepal • 26 September 2014

During my childhood, I spent every summer in Brittany, on a small island without running water or electricity. I learnt to economize on resources. So I don't feel out of place when I find myself on the other side of the world, on an isolated farm with no mod cons. I feel good. I don't miss anything, nothing that's superfluous.

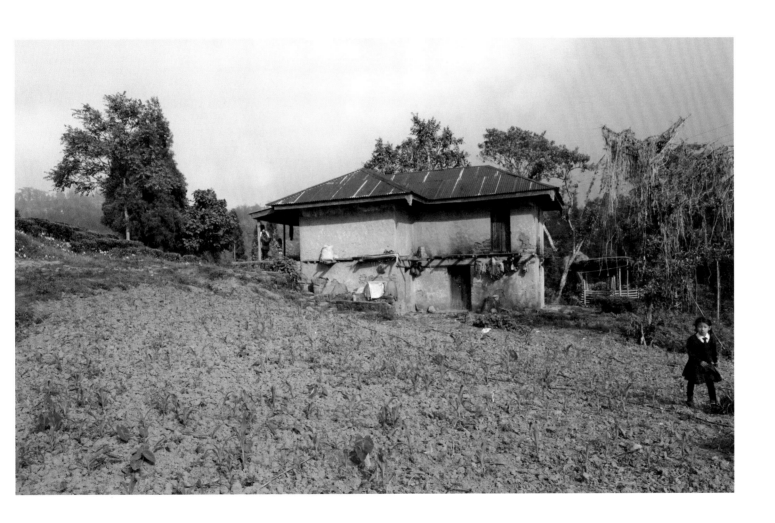

DOING THINGS DIFFERENTLY

Ecology is rarely a priority for politicians, but why should we expect them to do everything? Why complain that the environment doesn't play a big enough role in political debate or manifestos, and wait passively for things to change at the next elections? We expect politicians to do everything. What if we took matters into our own hands? In terms of the environment, our power is not limited to ticking a box on a ballot paper. Our purse, for example, represents a lot of power. If we don't want a plastic bag, we can refuse one. If we don't want a whole heap of packaging, we can refuse it. If we don't want animal cruelty, we can start by eating less meat. Eat it a bit less often and buy meat from animals that have enjoyed a healthy life, outdoors, raised by good farmers who care for their welfare. Or fish caught by conscientious fishermen, and not by trawlers that scoop up everything in their path and decimate the seas. We can buy fresh, seasonal produce; we can buy local whenever possible. We can buy from the producers themselves rather than from supermarkets. Each one of us has the power to help limit the often disastrous consequences of the food industry, which produces on such a large scale. We can avoid ready meals. We can stop buying pointless chemical products: people criticize farmers' practices, yet they smother their own gardens with weedkillers and fertilizers. We can recycle, we can reduce our consumption. We can compost, we can grow our own food. We can think as a community. We can help each other, give to others. We can upcycle, we can cycle. We can cook, we can keep animals. We can walk.

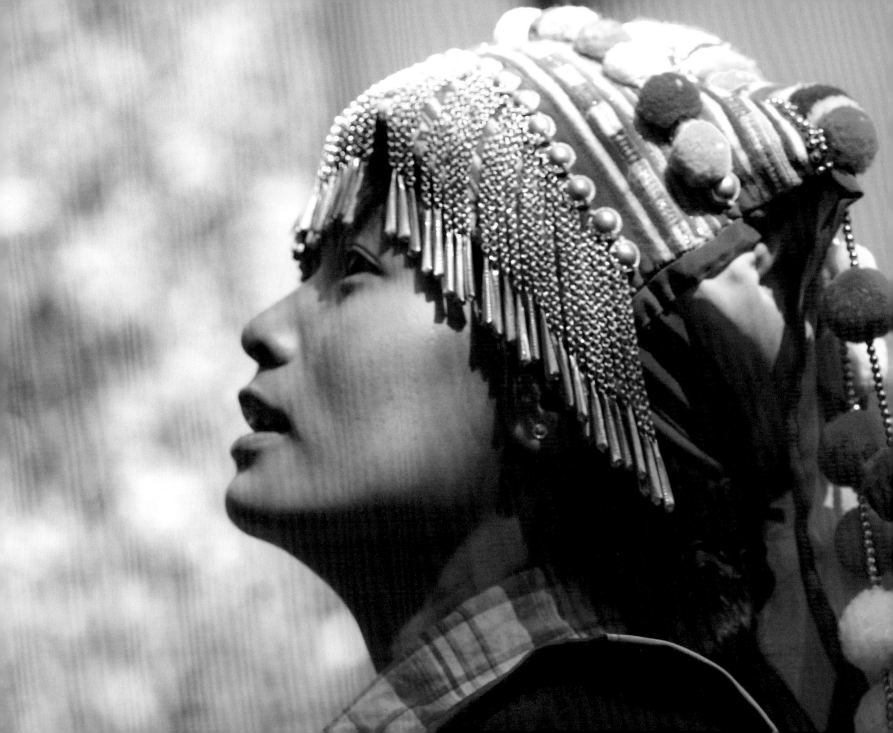

IN KOLKATA
India • 15 April 2011

A kid comes up to me as I walk through Kolkata. He asks me to take his photo. He lives on the street, surviving by collecting rubbish, which he sells for next to nothing. I agree to take his picture and suggest he smiles, and above all removes the plastic covering his face. He doesn't. He stares intently into the lens. He sniffs the glue in his bag at the same time, incapable of stopping.

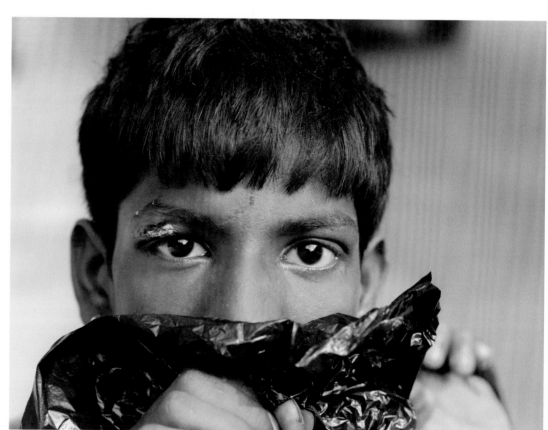

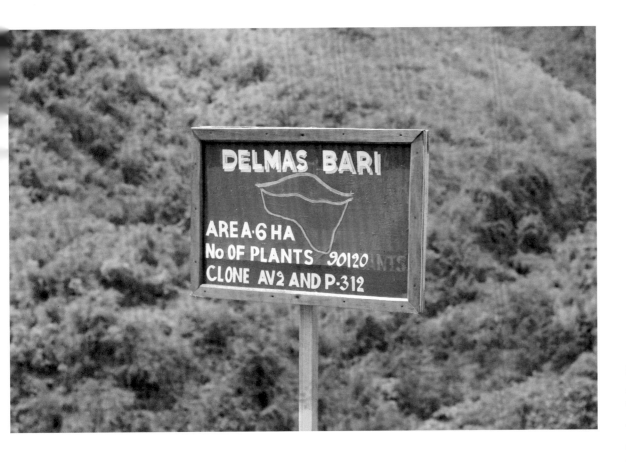

DELMAS BARI

AREA·6 HA
No OF PLANTS 90120
CLONE AV2 AND P·312

THE FIRST TEA FROM DELMAS BARI

India • 22 May 2012

It must be nearly ten years ago that a plot on the North Tukvar Estate was named after me. In high season, these acres produce a remarkable tea thanks to the planter's skill, of course, but also because of the quality of the tea plants selected. They're among my favorites.

For the first time, a single batch of tea from this plot has arrived in Paris. For fans of delicate, fruity, vegetal notes and white floral scents, this is its name: Darjeeling North Tukvar DJ14 Delmas Bari.

THE DIFFERENT FACES OF CHINA

China • 17 May 2013

People talk a lot about how China is modernizing, and it's true that the country has developed at an incredible rate over the past thirty years. Nonetheless, nothing delights me more than to travel around China's countryside and small towns. Taking a detour down a cobbled backstreet, you come across villagers who sit on their doorsteps, a bowl of noodles in one hand and a pair of chopsticks in the other, chatting away for hours. This is the gently paced face of China.

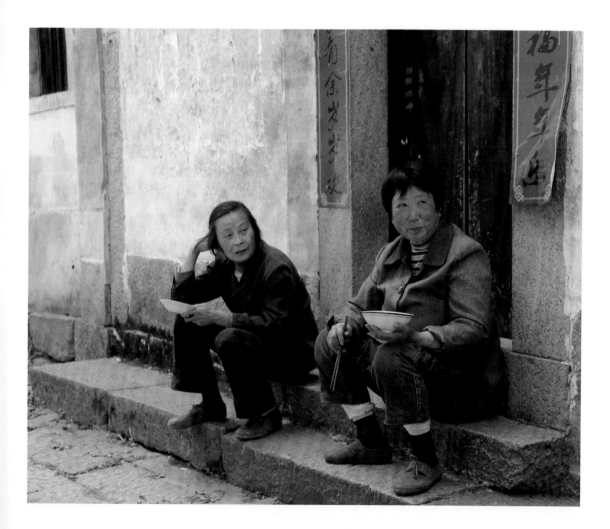

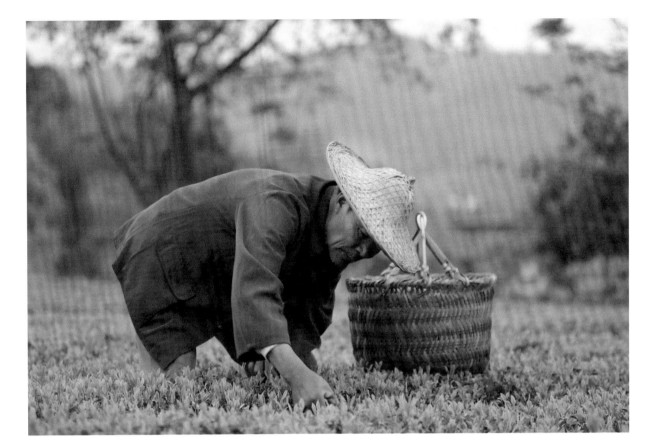

The process of buying tea in China isn't what it used to be. Twenty years ago, only the state had the authority to export tea, and every Chinese tea was entered in a special register. Expert tasters would travel the whole country, visiting each tea factory to taste each tea and give it a reference number. For example, a Grand Yunnan Imperial corresponded to a grade of 6112. Things have changed a great deal since then. Today those state experts have gone, no doubt to the private sector, and domestic consumption has increased dramatically. Demand now outstrips supply, pushing prices up. And nobody would think to remember how it was done twenty years ago.

THE CHINA OF YESTERDAY AND THE CHINA OF TODAY

China • 24 January 2014

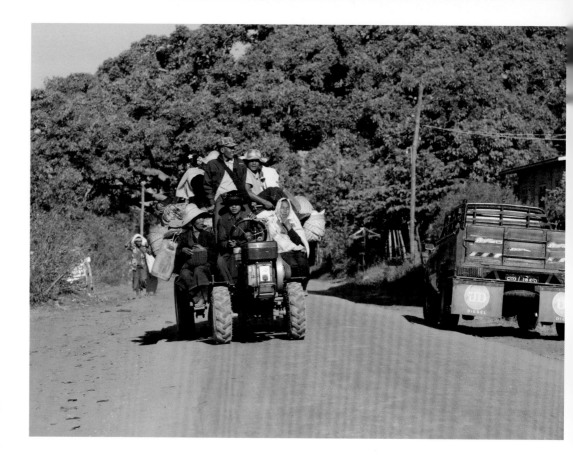

UNFAMILIAR TERRITORIES
Myanmar • 22 January 2013

My quest to unearth the world's finest teas often finds me traveling familiar roads, whether in China, India, Japan, Nepal, or Korea. Sometimes, though, I need to take a different route. Exploring new areas is part of my work as a tea researcher, so I'm on my way to the north of Shan State and the mountains of the Golden Triangle. I've heard it said that the main tea-producing region of Myanmar is in Namshan.
I'm ready for all sorts of discoveries!

HIMALAYAN
MISTS

Nepal • 13 June 2014

I'm writing to you from paradise,
From a plantation in the middle of nowhere,
Right at the bottom of a valley in Nepal.
A plantation worth finding after hours of walking,
Hidden in the Himalayan mist,
A plantation that makes its tea from the crops of an association of small producers,
A plantation so isolated that the number of visitors can be counted on one hand,
An unknown plantation whose teas are nonetheless worth the detour.
A plantation named Mist Valley.

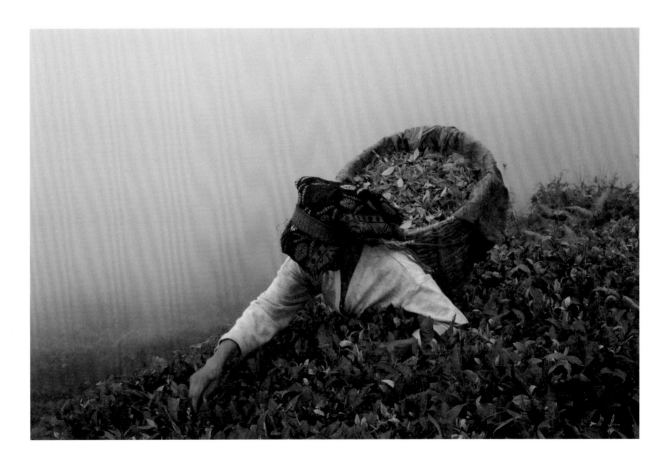

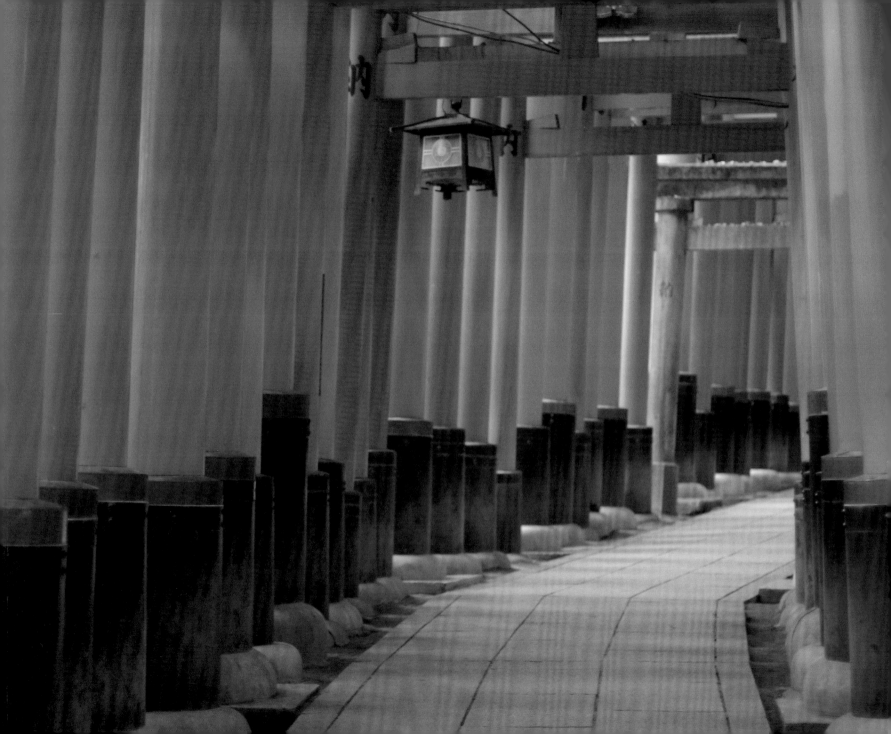

FUSHIMI INARI-TAISHA SHRINE

In a city like Kyoto, with more than a thousand temples, there is not one dedicated to tea. It's not very fitting for a country where so much of it is drunk. Last month, a little disappointed by this observation, I have to say, I decided to make do with the rice god instead, and set off to visit his temple. I'm glad I did, because it means I can bring you an image of the wonderful red pillars of the Fushimi Inari-Taisha shrine. This Shinto temple has thousands of these beautiful *torii*.

DEPARTURE FOR INDIA

India · 2 November 2012

I took off for India this morning.

I'm not yet traveling on a prayer mat or on one of these flags fluttering in the wind, but I'm not unmoved by the intense mystique of this country and its poetic charm.

These pieces of cloth symbolize the sky, the earth, water, fire, or air, depending on their color. On each flag are printed prayers that are carried off by the wind.

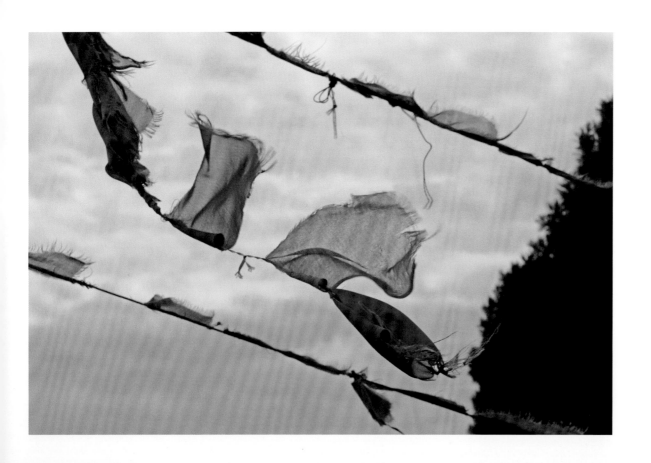

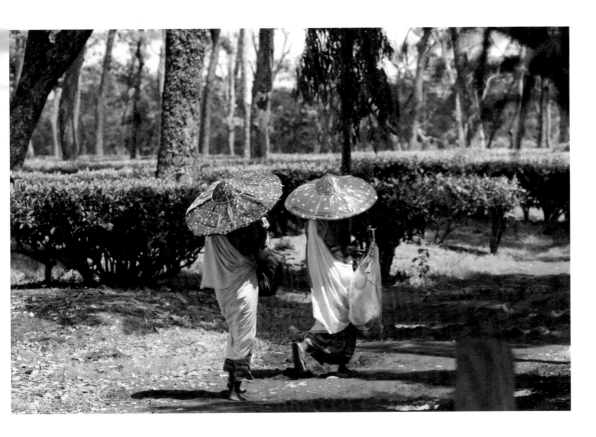

TAKING SHELTER

India • 27 December 2011

Two tea-pickers in the Assam region returning home to their village after work. I think the sight of these women protecting themselves from the sun's rays beneath their pretty parasols brings a touch of warmth to our gray winter. In this season, Paris lacks bright colors. Apart from the inevitable Santa here and there outside the department stores, you don't see much red. It's funny to think that somewhere else on this earth, people are taking care to protect themselves from the sun, while here, the slightest ray of sun makes us close our eyes and purr like cats.

Red is also the color of some chilies, so I'll take this opportunity to tell those who've never tasted Assam teas that they develop subtle notes of tobacco, honey and... spices.

MAGNIFICENT CHINA GREEN TEAS
China • 17 April 2012

Every year, in mid-April, my attention turns to China. This is the time of year when processing begins on magnificent China green teas such as Long Jing, Bi Luo Chun, and Bai Mao Hou. Right now, I'm not far from Suzhou, on the shores of Lake Taihu. Every day I do my best to nap in the tea fields. This is the kind of view I get when I wake up.

ZHAJI HAS
KEPT ITS SOUL

China • 12 July 2011

Every time I go to China, I wonder what else will have changed in the cities and countryside that I know. The rapidity of change in the country takes your breath away as you gaze upon a street you no longer recognize, or a forest of skyscrapers that in less than a year has grown faster than a copse of bamboo.

But off the beaten track, there are hamlets that still have their soul. Here, in Zhaji, in Anhui province, nothing has changed for a very long time, and every evening after his meal, Mr. Li walks beside the river before returning home for a last cup of the excellent tea he produces.

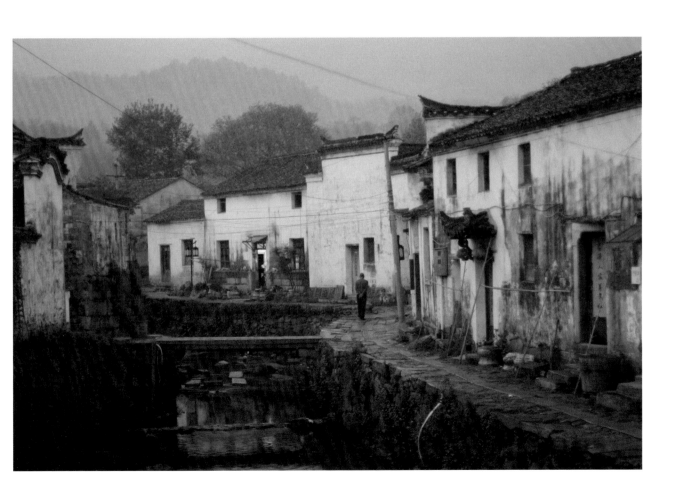

– QUEST

WHERE TWO WORLDS MEET
Malawi • 18 November 2016

A tea plantation, a farm that produces tea, has all of life in it. Wherever tea is grown, wherever it's processed, there's both an agricultural aspect and a human aspect. Tea is where these two worlds meet: plants and people. So when I meet tea producers, I naturally take an interest in every part of life on the farm: the quality of the tea, of course, as well as the plants and soil, and how well they're respected. I also pay attention to the quality of the environment, the forests and rivers, the quality of housing and the treatment workers receive if they're injured, the quality of preventive measures put in place and, most of all, the quality of education.

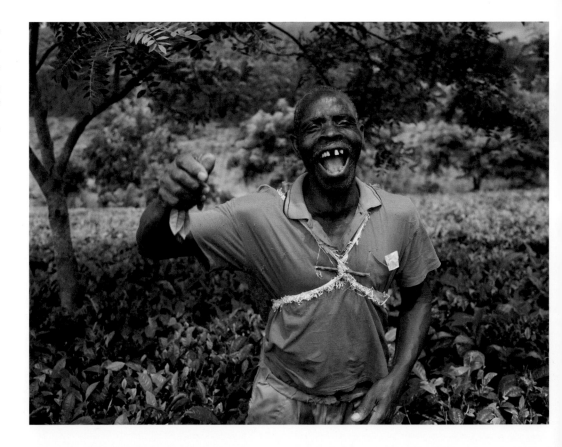

A few days ago, I bought a wonderful third-flush (fall) Singbulli, and this morning I've just confirmed the purchase of a Rohini, also harvested in November. The first batch only weighs seventy kilos, the second batch just a little more, and they will arrive in France in December. Those of you who love fine Indian teas must remember that Darjeelings produced in March, June, and the fall have very little in common. The reason is that this mountain you see here, Kanchenjunga (8,586 meters), creates a great contrast with the weather conditions on the plains of the subcontinent. Darjeeling is one of the tea-producing regions with the most varied climate. In warmer seasons, the southerly wind brings some of the stifling heat of the plains to these mountains. On the contrary, as winter approaches, the peaks make their presence felt, the sky clears and the temperature drops. And the growth of the tea plants gets slower and slower, which is another reason for the variations in their flavors.

FIRST FALL DARJEELINGS
India • 2 December 2011

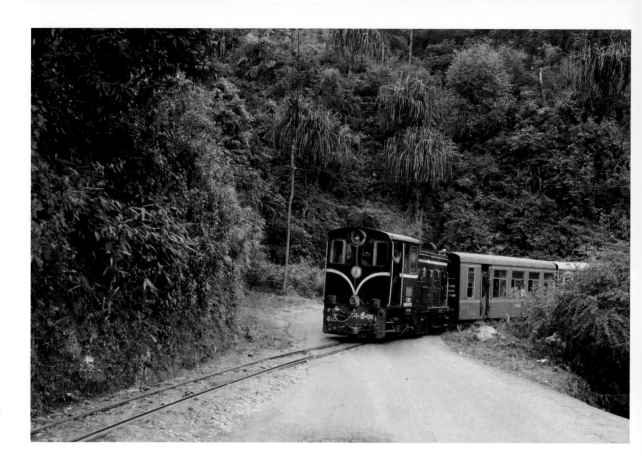

THE DARJEELING
TOY TRAIN

India • 5 March 2010

These days, when everything must be fast, modernization has also affected the Darjeeling Toy Train. For one of its daily services, the steam train lets out a big sigh and takes a break to make way for a diesel engine, pictured here. This bit of progress is to be avoided, then, unless the journey itself is not your purpose and all that matters is to arrive.

The day before yesterday, Darjeeling was hit by a hailstorm, which wasn't good for the tea plants. What with the late start to the season due to the lack of rain, and the violent weather decimating the leaves, the planters don't know which saint to pray to. They've had enough of these insults from the skies. They never want to see so many tea plants battered in the space of a day again.

A HAILSTORM IN DARJEELING
India • 6 April 2012

IN PRAISE OF
SLOWING DOWN

Rwanda • 8 July 2016

There's something no planter will ever stop me from doing, and that's walking—setting out on foot for at least one or two hours, every day. I love it. Alone or in company, either way, I love to walk, I love meeting people, observing the changing light and weather, the beauty of blossom, the color of cloth. I like to sit down on a doorstep and exchange smiles with people I know nothing about but with whom I share a connection, because we live on the same planet, of course, and also because tea probably plays a part in their lives too. You can learn a lot by walking: about the way people live, the methods they use to grow tea, the weather, the geography, and then all those colors and smells. There are strange creatures too, sometimes snakes that are completely unknown, weird insects, "things" that jump. But I feel good. I sit on the edge of a rock when I want to admire something, when it's beautiful, and simply because it's good to take one's time, to ask oneself what our purpose is on our small planet, to ponder the meaning of life. Tea makes you slow down. And tea also teaches you to be still, to learn to breathe, literally and figuratively, it teaches you to stop being so restless, running around from morning to night without really knowing why.

Here, three hours north of Kigali, on the little paths that wind through the mountains, there's a lovely way to say "hello." When you come across someone else, they greet you by raising their arms as if you're a long-lost friend, with a joyful *Amakuru!* This hello means "what's the news?"

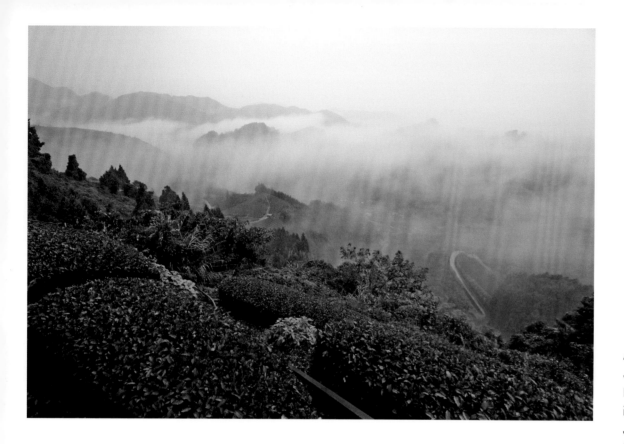

GYOKUROS AND SENCHAS IN THE CLOUDS

Japan • 5 November 2010

A typhoon has just swept through Japan, from the south to the north. I don't know what delayed it, because it was very late; typhoons normally hit Japan in September. Violent winds flip your umbrella inside out and rain drenches you from head to toe. It seems I didn't choose the best day to visit Ryogochi and admire these mountains, where some very high-quality Gyokuro and Sencha teas are grown. However, this abundance of clouds does add to the mystery of the place. Although the village itself is slightly hidden, along with the River Okitsu, you can still make out some shapes, and it is very Japanese to suggest, rather than to assert.

Recently, an elegant creature slid silently between the branches of a tea bush, level with my waist. Tea bushes are planted close to each other to make harvesting easier, which means that when you decide to venture into the middle of the field, your feet are completely hidden from view. So you walk looking straight ahead, moving as best you can. You don't pay attention to the many creatures living in these humid conditions. The man behind me stopped me suddenly because he'd seen something yellow near my left arm, undulating beneath the foliage. A few minutes later, he held it out on the end of his stick, so I could take a photo of this fine-looking snake, whose name I'd like to know. It was as beautiful as a rare jewel, as supple as a necklace, and it gleamed like gold. Before leaving us, overcome by shyness, the snake took the time to make something resembling a heart with its body, expressing all the love that nature offers us when we respect it.

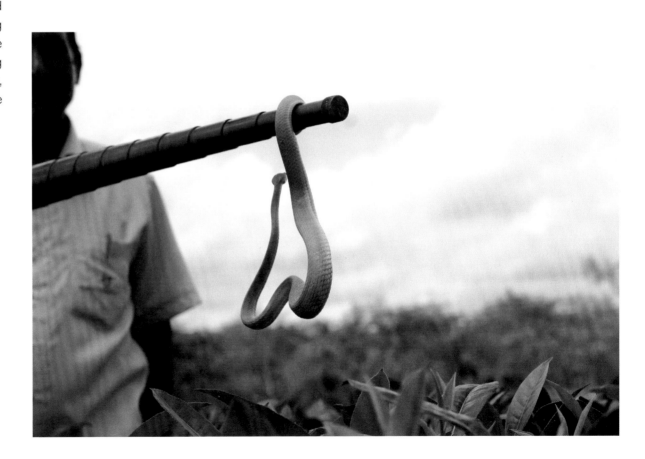

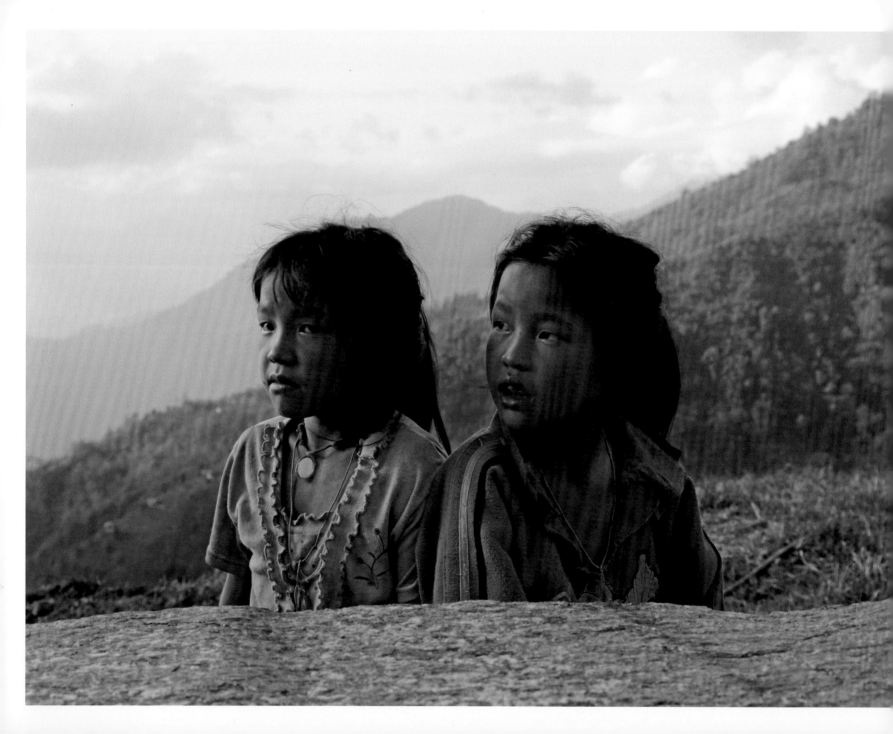

— PORTRAITS

Wen Rong Tian has had two lives: the first as a physical education teacher, and the second, which began twenty-seven years ago, as a tea producer. From the first he has kept his love of a healthy life and follows a daily program of vigorous exercise and a strict diet. The second came from his father, who managed a tea factory for twenty years. Son has surpassed father, however: today, Wen Rong Tian is one of the main, if not the leading, producers of black tea in Yunnan. He makes excellent teas and even claims to have created the famous Yunnan Golden Buds and Golden Needle teas produced in the province. I visited him near Baoshan, where he lives. His passion lies not so much with walking though tea fields as spending all his time tasting his teas and improving production processes. He lives, sleeps and eats just a few meters from his factory. What gives him the most pride is to make some of the most amazing teas in the world from simple leaves. Unlike many Chinese producers, he prefers black teas to green teas, for their generous aromas and smooth presence.

THE TWO LIVES OF MR. TIAN

China • 17 November 2017

THE PLANTER ANIL JHA, CONCENTRATING

India • 8 April 2016

Here's a photo I took in April of Anil Jha, one of the three most respected planters in Darjeeling. He's concentrating on the smell of the damp leaves that are in the lid of the tasting set.

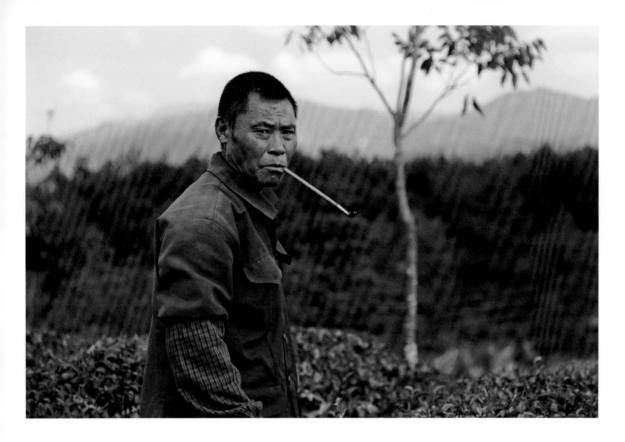

MR. HUANG,
A DISPLACED
WORKER

China • 31 October 2019

Mr. Huang is one of millions of Chinese workers who've decided to leave their native region to earn a living elsewhere. It's much easier to find work in the wealthier coastal provinces than in the interior of the country. Every year, Mr. Huang leaves Guizhou, where he was born, and where he grows vegetables in a mountain village, and travels to the Wuyi Mountains in Fujian. There, inhabitants' incomes have increased significantly, and people no longer want to work in the fields, preferring to live in the city. So Mr. Huang goes there to work on a wonderful organic plantation. He tends to the tea plants and helps with the harvest from early March until the end of September, before returning to his family in his own province. And every year, he never hesitates to repeat this journey, for a monthly wage of 5,500 yuan.

A HMONG TEA-PICKER

The Golden Triangle is a fascinating region thanks to its varied geography, mountainous jungle, hidden valleys and, most of all, the many and varied ethnic groups who have made it their home. Each ethnic group has its own culture, language, and customs. From one to another, the styles of houses change, their relationship with the land changes, the food changes.
Here in Sung Do, in northern Vietnam, a woman sets out to pick tea leaves from hundred-year-old trees.

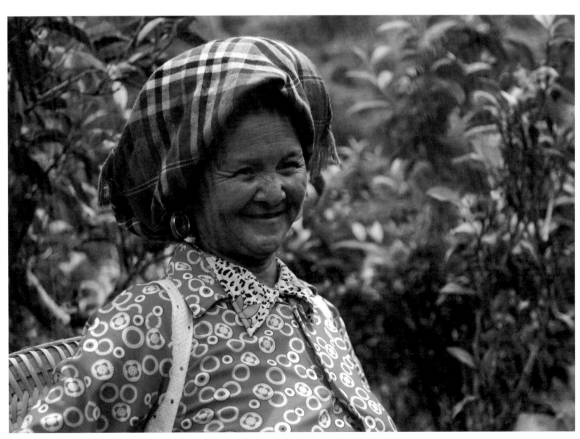

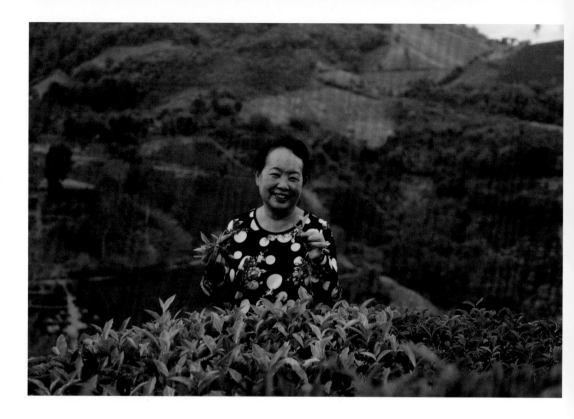

In the world of tea, Mrs. Ming is very unusual. There are very few women in charge of a tea plantation. Not only does Mrs. Ming produce some incredible Oolongs, she's also a pioneer, because she introduced tea to the area around Mae Salong. Since then, producing lightly oxidized teas in the Taiwanese style has become fashionable in this area of the Golden Triangle, on the border between Thailand and Myanmar.

I met Mrs. Ming nearly ten years ago thanks to Augustin, one of my nephews who was traveling through these remote mountains on his motorbike. I'd asked him to let me know if he came across any tea plants.

Mrs. Ming reserves her best teas for me—Jade Oolong, Ruby Oolong, Milky Oolong, Thai Beauty—along with that type of friendship that lasts a lifetime. Bold and exacting, Mrs. Ming never rests on her laurels. She experiments, innovates and tries out black and dark teas, with success.

MRS. MING, A PIONEER
Thailand • 21 December 2019

FACES AND MEETING PEOPLE

Nepal • 15 June 2018

I didn't know this lady. She was just standing outside her house, opposite a tea factory. I liked her pretty purple hat and the touches of purple under her coat set against the purple backdrop behind her. I knew nothing about her except where she lived; we simply smiled at each other and I held up my camera, by way of asking if I could take her photo, and she agreed. There she was, and here she is now. I'm so happy when I'm traveling, walking down lanes in remote villages, or through fields. I'm so happy to photograph these men and women, to exchange a few words. We laugh and often we sit for a while together, on a bench, a step, a stone, anywhere will do. We get to know each other, just a brief encounter, then I go on my way again. And I'm happy to share them with you, these faces, these moments; to me, that's just as important.

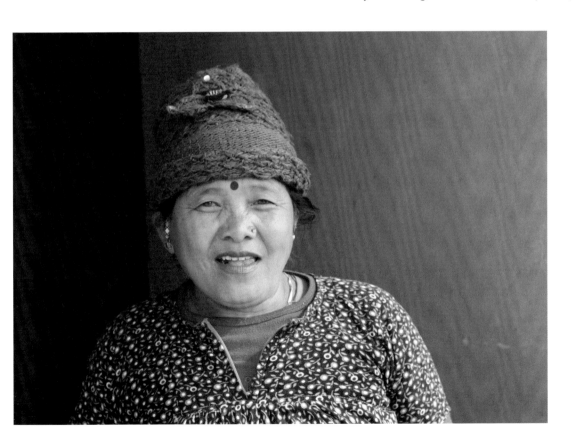

A TENDER LOOK OFF
THE BEATEN TRACK

Nepal • 22 May 2015

This woman is ninety-five. She lives on an isolated farm with her husband. They live alone on the mountainside, far from any other houses, with just a few chickens and a little land to cultivate. A tiny path leads to their house. It's so narrow you must place one foot in front of the other. I visited them last week, while walking in the mountains in eastern Nepal. I was with Andrew, the planter from Guranse who shares my love of long walks. The woman made us tea while we chatted with her husband. She brought us the tea in a metal tumbler and threw a handful of cereal into a small, separate bowl. We poured the milky tea, which was quite peppery, over the cereal, and ate. We drank the remaining tea. We talked for a long time with her and her husband on their doorstep, beneath a beehive. They talked nonstop. She understood my mediocre Hindi but spoke only in Nepali. Andrew translated for me. When I managed to get a word in, I asked her questions. What was her secret for a long life? Eating healthy food; fresh, home-grown produce. And was not love also the secret of their longevity? She laughed and exchanged a tender, incredibly touching, look with her husband. They married when she was eleven. He was fifteen. They love each other. They've been together for more than eighty years. When it was time for us to leave, they took our hands, and they blessed us by placing their hands on our foreheads. And they asked us if, later, when they're no longer there, we could think of them, just once.

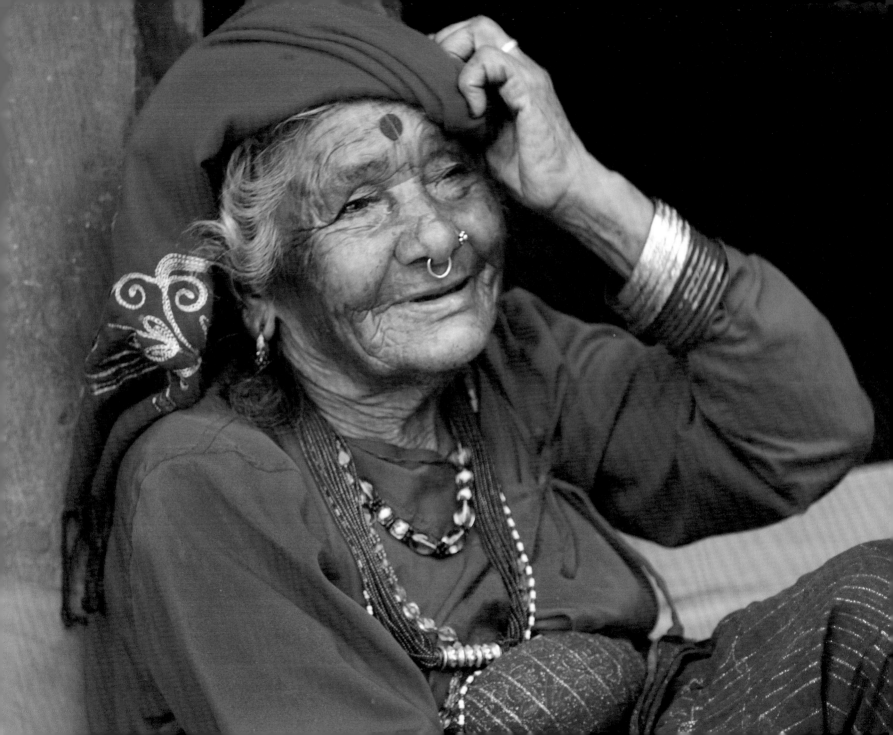

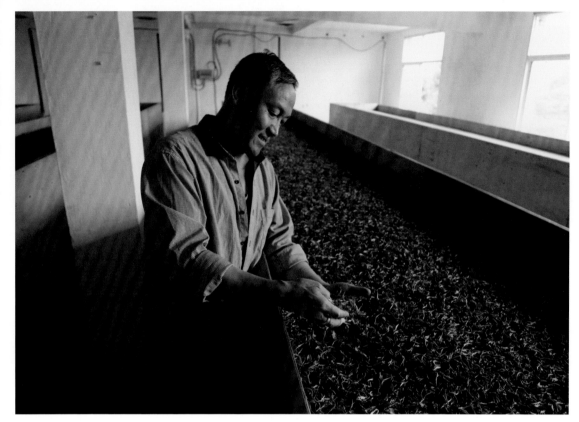

MAKE TEA NOT WAR

China • 15 September 2017

I got to know Xuan Dong Wu this summer. I met him in the Ming De factory he manages and where, that day, he was overseeing the withering of the tea leaves with the greatest attention. Xuan Dong Wu loves his job. He hasn't always been in the tea business. He started out in the army and fought in the Sino-Vietnamese War in the early 1980s. He then returned to the village where he was born, and where tea provides most of the work. He makes white teas, Pu Erhs and black teas that are considered the best in Yunnan. He likes to introduce new ideas, and is responsible for several of our Mao Chas, the intermediate teas used to make Pu Erh. Xuan Dong Wu is a shy man and didn't say much when I asked him what he wanted me to write about him here. He simply told me about his life, and what he likes. He said he likes making tea with his heart by putting effort into it, he said he wanted to do his best and make the best teas possible. And then he plunged his hands back into the withering leaves and didn't take his eyes off them.

I met Rana Bahadurdiyali a few days ago in Ilam Valley, in Nepal. Twenty-four years ago, Rana founded the Teenjure cooperative, which today has no less than 234 farmers who combine their tea production. This year, Teenjure has started to produce some very good, interesting and varied teas. When I asked Rana what he wanted me to write about him, he told me how hard everyone had worked, how challenging it was for the whole community of Teenjure to start growing tea—clearing the land, planting the tea plants, building the factory and installing the equipment. Twenty-four years ago, when they began this project, they had no water, no road, no electricity. It took them two years to build the factory, Rana, aged eighty-two, tells me, smiling.

RANA BAHADURDIYALI, FOUNDER OF THE TEENJURE COOPERATIVE

Nepal • 2 June 2017

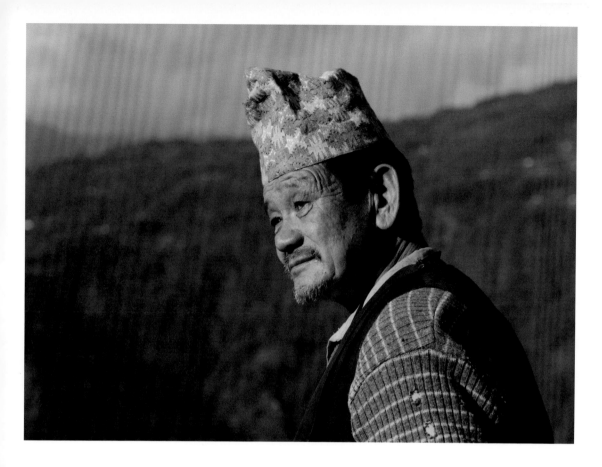

YAAD BAHADUR LIMBU, "TEA FATHER" OF SOYAM

Nepal • 5 December 2014

In his village of Soyam, Yaad Bahadur Limbu is known as the "tea father." He was the first to plant tea in the village, and today, tea is its main source of income. Everyone is involved. To reach Soyam, you must cross a suspension bridge and then climb for several hours. You pass terraced rice paddies and fields of millet, and cross farmyards. When Soyam's villagers harvest the tea leaves, they're transported on horseback. This requires four or five horses. They take the same path as the one that had me huffing and puffing, and they cross the same suspension bridge. Each horse wears a pack saddle allowing it to carry a load of a hundred kilos. The caravan takes five hours to reach the factory and must return to the village the same evening. It's a long expedition.

Ye Yingkai, pictured beside me, is a great connoisseur of Fujian teas. His story is unusual as he started out working for the state corporation in charge of tea exports in his province, before forming his own company. He then acquired a farm, fields, in order to produce his own tea. He also tracks down for us superb Tie Guan Yin, rare Da Hong Pao, and extremely fine jasmine tea.
He's been working with Palais des Thés for nearly twenty years, and naturally he's a great friend of mine.

YE YINGKAI, A PRODUCER OF FUJIAN TEAS

China • 9 July 2010

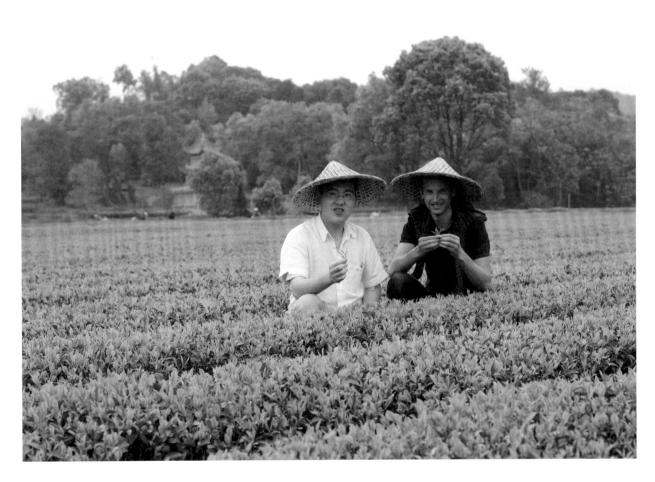

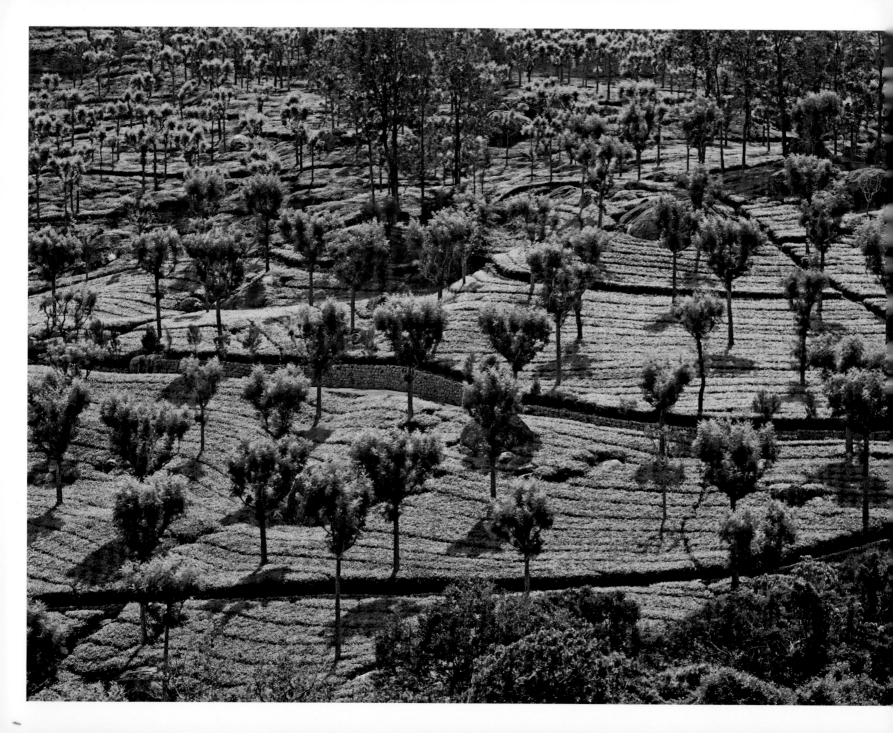

— GROWING

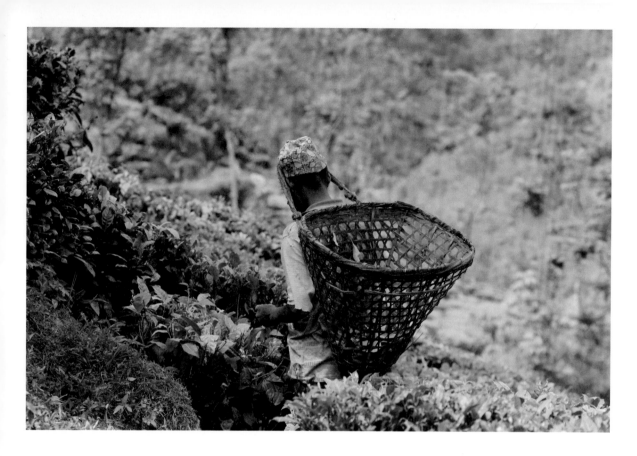

FIRST STEPS

Nepal • 6 September 2019

For those of you just starting to explore tea, here are the basics you should know about the plant. Tea comes from *Camellia sinensis*, a variety of camellia. Several times a year, new growth is plucked from this evergreen shrub and is processed into different types of tea (green, black, white, etc.). The color of the tea comes not from the shrub itself, but from the way the leaves are handled after harvesting. Tea plants thrive in regions with a hot and humid climate, preferring acidic soil and regular watering throughout the year. Finally, altitude (tea plants grow at up to 2,500 meters) enhances the quality of tea while reducing yield.

When it gets really hot, tea plants benefit from a few hours of shade every day. So in regions where temperature can soar, trees are planted above them. We are like the tea plants, dreaming, as we walk around town, of leafy trees that would shade us from the sun and excessive heat.

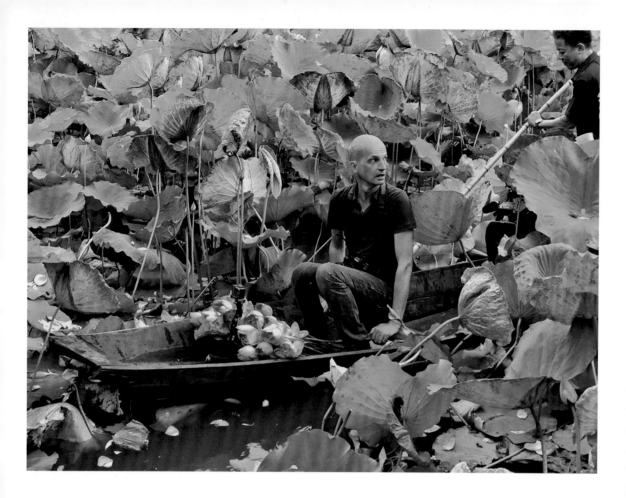

GETTING WET
Vietnam • 12 July 2019

Lotus tea is a Vietnamese tradition. To grow the flowers, you must get wet. You get wet when it's time to harvest the flowers. You get wet in the pond, either wading through the chest-high water or in the little leaky boats. And you get wet when it's time to divide up *Nelumbo nucifera* by plunging your hand down toward the bottom and grabbing a few rhizomes, which will be planted out in another pond. Making the tea requires patience, as the tea leaves are left in contact with the flower pollen for five days in a row.

The tea-producing regions of Southern India are mainly located in Tamil Nadu (around Ooty and Coonoor) and Kerala (Munnar and Wayanad). Although the teas from these areas are not known as the best in the country, if you look carefully you can find plantations producing some really good teas. Like here, in the Wayanad region, with the Western Ghats in the background, and Chembra Peak.

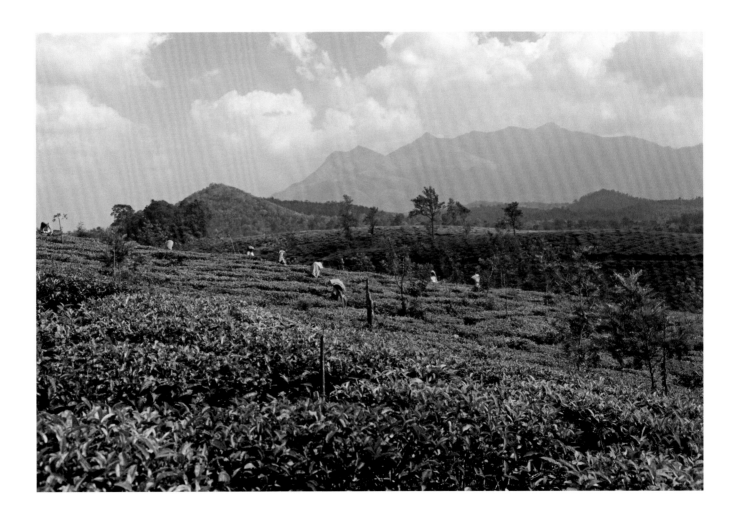

The Mist Valley plantation takes its name from the lingering mist that envelops the mountains in this region of Nepal. However, from time to time the wind blows away the fog, the clouds dissipate and the sky clears completely. Then this magical landscape is revealed, with the tea fields that appear to hang in the sky, undulating like flying carpets, ready to carry you off over the Himalayas.

LIKE A FLYING CARPET
Nepal • 20 June 2014

Because tea plants don't like frost, Japanese tea fields are populated by strange shapes. When their blades are turning at the top, these fans prevent freezing air from stagnating above the bushes.

STRANGE SHAPES
Japan • 22 November 2013

GROWING ROOIBOS

South Africa • 31 August 2018

In South Africa, the only country that produces Rooibos, 350 farmers grow it as a crop. Australia and California tried to grow Rooibos but failed. Rooibos is harvested when temperatures are high, often by workers from neighboring countries.

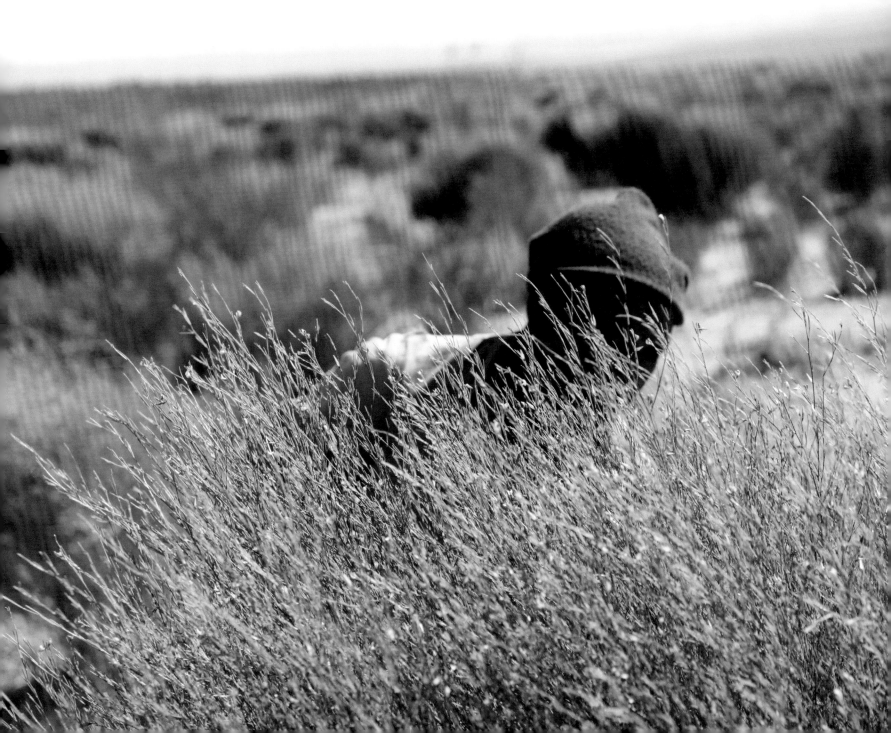

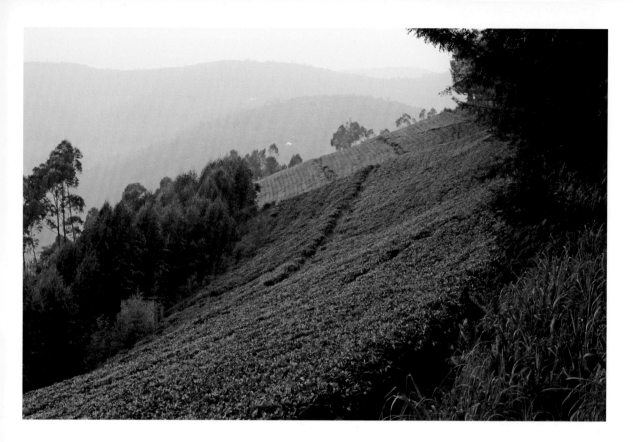

COMMON SENSE
Rwanda • 18 January 2019

A farmer who grows tea might have to deal with various threats to his crop: insects (spiders, mosquitoes, etc.) that damage leaves, caterpillars that like to eat young plants, or fungi that grow up the trunks of the bushes. But there are solutions to these problems that don't involve pesticides. One is to encourage the presence of birds and other predators by growing hedges near the tea plants. Another important factor is altitude: pests are much less of a problem at low temperatures. Nature must be respected, and tea should be planted in a suitable environment. In the same way that we don't build a house in a bog, tea should not be planted in an environment that is too humid, at low altitude, on flat, undrained land that is intensively farmed and stripped of all other trees and plants. In those circumstances, it is likely not to be organic. It makes sense when you think about it.

HOLDING THE SOIL IN PLACE

India • 19 January 2018

Farming methods change over time. Tea bushes sometimes used to be planted following the slope of the ground, resulting in vertical lines like those visible on the left of this photo. Today, young bushes are planted in horizontal rows, to reduce soil erosion. In heavy rain, the water runs off more slowly and the tea bushes hold the soil in place.

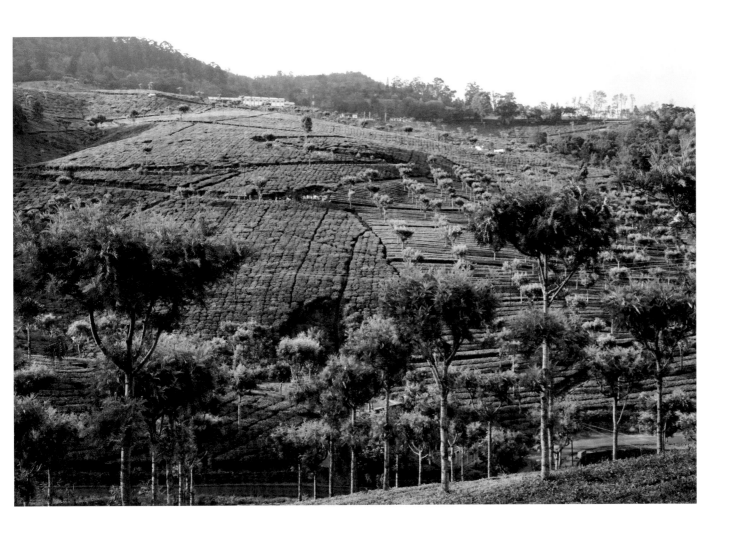

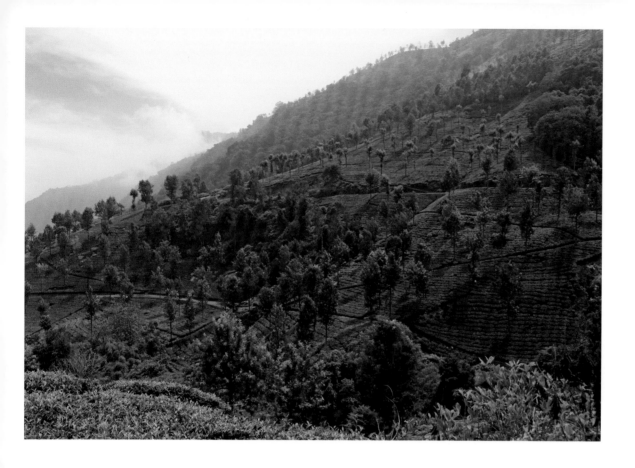

AN ALTITUDE WELL SUITED TO TEA PLANTS

India • 2 February 2018

When you think of Southern India, you think of colorful temples, ancient spice-trading posts, beaches lined with palm trees, boats gliding along complex networks of canals and backwaters, and luxuriant gardens. Southern India is less well-known for its mountains. Yet the Ghats, literally "steps," peak at more than 2,000 meters above sea level. This altitude and climate are well suited to tea plants.

In the foothills of the Dhauladhar Mountains, a stone's throw from Kashmir, a few tea plantations are well worth the detour, not only for their majestic view of the Himalayas but also for the hard work of several local producers, which is unquestionably paying off. For decades, the region produced a relatively ordinary green tea for local consumption, but more recently, if you look hard enough, it has become possible to find a wide variety of more artisanal teas to delight the palate. All while admiring the view of the Dhauladhars, of course.

IN THE FOOTHILLS OF THE DHAULADHAR MOUNTAINS

India • 6 October 2017

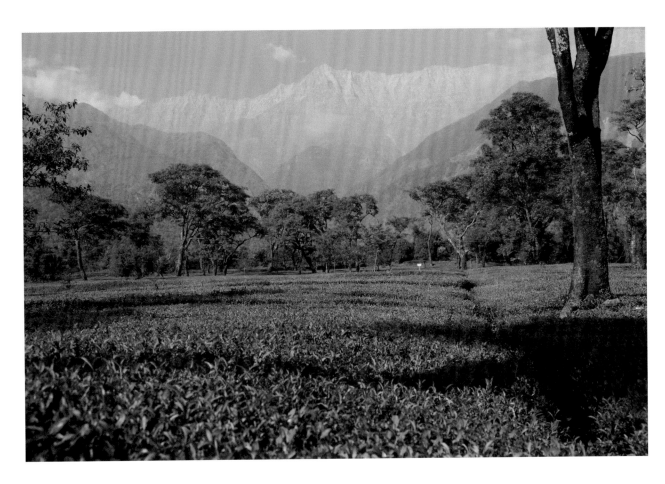

A VERTICAL GARDEN

Taiwan • 30 September 2016

Tea is very good-natured. It gets on well with many plants. Here, high up in Taichung, in Taiwan, it has a close relationship with *Areca catechu*. This palm provides the farmer with a supplementary income and the bushes with a little shade. It also lends an impressive verticality to these tea gardens, which are usually very horizontal.

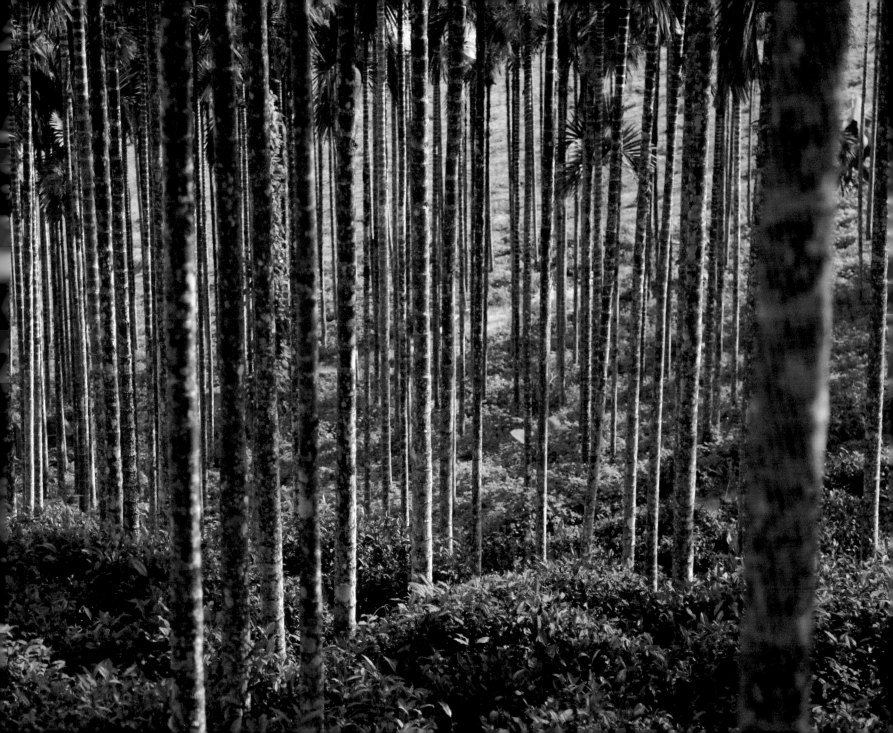

THE END OF THE MONO-CULTIVAR IN JAPAN

Japan • 3 March 2017

A few decades ago, the country could be described as mono-cultivar and most growers used the Yabukita variety of tea. Happily, today, there's an increasing number of cultivars in Japan, such as Sae-midori, Oku-hikari, and Asatsuyu. A greater range of cultivars means that once the tea is infused, it produces a wider palette of aromas and flavors. And that's good news for tea-lovers.

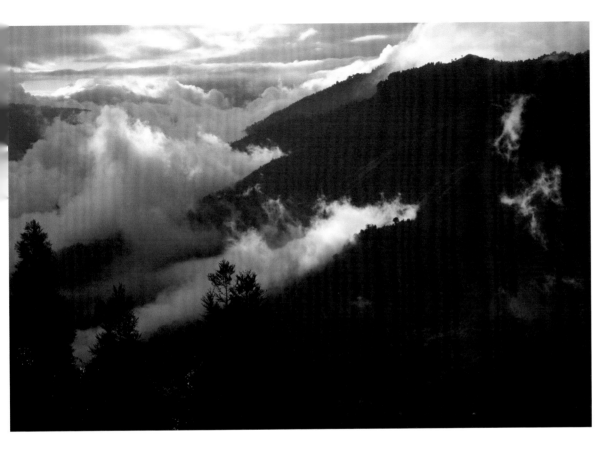

The landscapes of Darjeeling are among the most incredible in existence. Not because they're better than anywhere else in terms of their beauty, but because of the unique speed with which the scenery in this region changes. You can go from a hailstorm to a beautiful blue sky in less time than it takes to say those words, and the mist can be so thick that sometimes, while walking in these parts, you even lose sight of the ends of your shoes. After all, the name Darjeeling comes from the Tibetan *Dorje Ling*, which

"LAND OF STORMS"

India • 21 October 2016

means "the land of storms"; here, the skies rule. Naturally, these climatic variations and the extreme temperature changes that accompany them have a major influence on the quality of the tea, which is why, in Darjeeling and Nepal, the characteristics of teas picked in the spring, summer, and fall differ so much. In no other tea-producing region of the world do we see such variation between teas from one season to another.

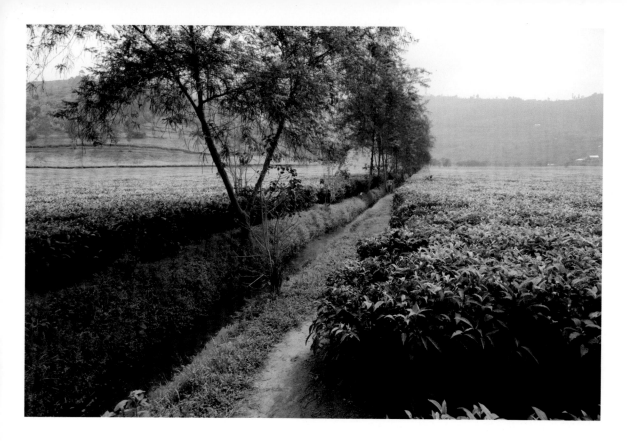

IRRIGATION AND DRAINAGE
Rwanda • 24 June 2016

Tea plants don't like to stand in water. When tea is grown on flat land, like here in Rwanda, it's important to dig out ditches so that the rainwater runs away and doesn't linger around the camellias' roots. What's clever here is that the drainage is designed not only to allow water to run off, but also to irrigate the crops during dry spells. For the system to operate, you need to be near a reservoir, or a river, so its water can be diverted into the channels long enough to fill them. The frogs love it, judging by the racket they make, and a whole ecosystem thrives in these damp conditions, including colorful kingfishers, which I've startled into flight a few times.

SPRING AFTER SPRING

Nepal • 20 May 2016

After Darjeeling, we turn our attention to Nepal, China, and Japan, to enjoy their new spring teas. In Japan, we return to the farmers we know, and we also enjoy discovering teas produced by others. In China, we're guided by the traditional appellations, which are attached to particular villages. In Nepal, we know which plantations are capable of producing the best teas at particular times of year. There is sometimes an added difficulty though, like here at Kuwapani. The planter, who was an employee rather than the owner of the plantation, has left. What will the results be like under his successor? We'll know the answer in a few months' time. Meanwhile, let's enjoy tasting the new teas this spring has to offer!

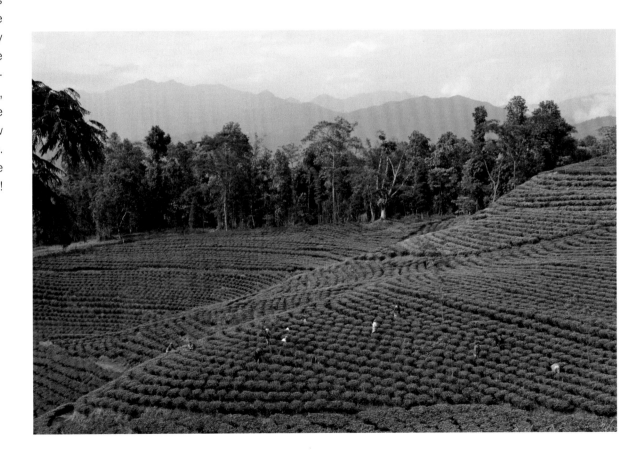

WAITING FOR RAIN IN DARJEELING

India • 4 March 2016

In Darjeeling, where I am right now, there wasn't a drop of rain in January or February. This means most plantations haven't started to harvest yet. Only the ones with plots at low altitudes, who irrigate their plants, have been able to produce a few batches. But here, the first teas are never the best. In Darjeeling, when you're looking for quality, you can never be in a hurry.

HEAVY WORK

Turkey • 4 September 2015

In most regions of the world, tea leaves are transported by tractor after being harvested. In Turkey, you see men carrying enormous bags. They tumble them down the slopes, over the tea plants, until they reach the road.

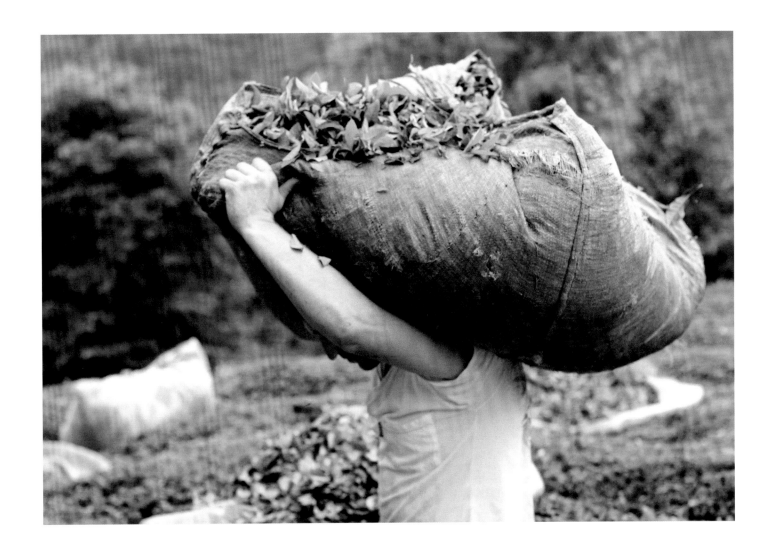

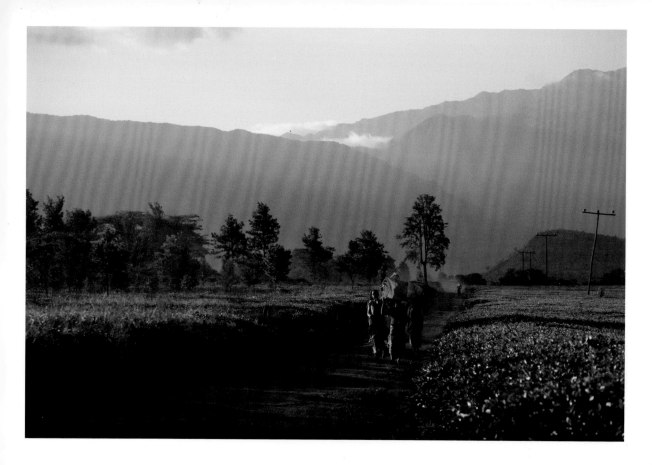

FROM ONE EARTH TO ANOTHER

Malawi • 29 May 2015

If I talked to you about *terre battue* in French—literally "beaten earth," the name given to the clay surface of tennis courts—you'd think I was referring to the French Open, which is taking place at the moment just outside Paris. Not at all. This brick-colored ground makes me think of the tea fields, those of Malawi for example. The path is like a scar cutting through the fresh green expanse of the tea plants. It's a million miles from the courts of Roland-Garros. And without the crowds. There, silence reigns.

THE STEEP SLOPES
OF DARJEELING
India • 9 August 2013

Camellia sinensis grows very happily on steep terrain, as it doesn't like water stagnating around its roots. In some regions of the world, like Nepal, or here in Darjeeling, the slopes are very impressive. As I travel around the countryside, I often discover a little village clinging onto the hillside above a field of tea. Sometimes you wonder how the pickers manage to harvest the leaves in such conditions.

FIRST HARVESTS
AT LOW ALTITUDES
India • 23 March 2012

In Darjeeling, at the beginning of every spring, the first estates to harvest are those situated at the lowest altitudes. They enjoy more clement temperatures. This is what the region looks like at the exact place where the immense plains of India take over from the foothills of the Himalayas. Here, you can see the Longview Tea Estate, and you can make out the ocher-colored stone bed of the Balasun River.

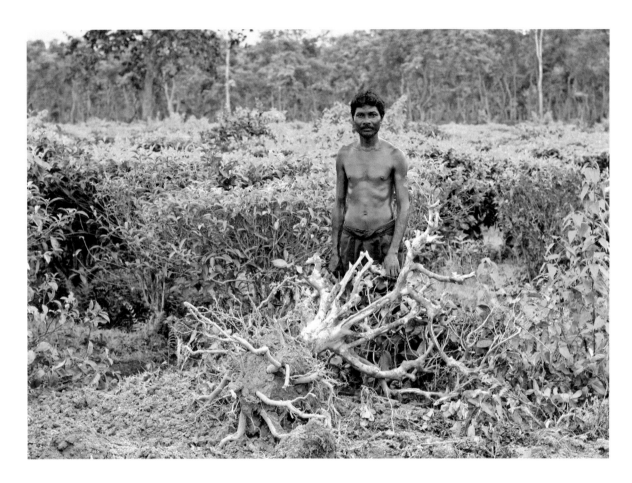

Pulling up a tea plant requires re-markable strength, as its roots plunge deep into the ground. But although the man in this picture is sweating heavily, it's not because he has achieved this feat. In fact, the bush has just been uprooted by a mechanical digger, and the man is simply hacking off the stump with a machete. He's sweating so much because the heat and humidity in this region of Assam are at their peak.

UPROOTING A TEA PLANT IN STIFLING HEAT

India • 27 September 2011

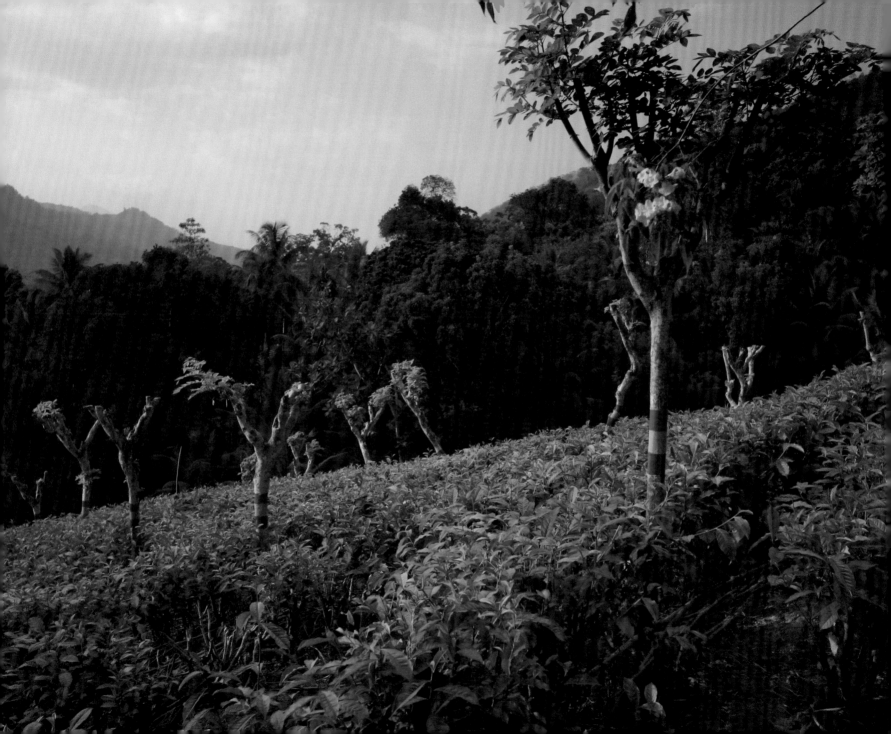

TRAFFIC LIGHTS

Sri Lanka • 14 May 2010

At New Vithanakande in the south of Ratnapura, in Sri Lanka, to keep the tea plants at the desired height, the trees serve as a kind of traffic light system: if you see green, the tea plant isn't too high, if the green disappears it's the orange that shows and the plants need to be cut lower, and if only the red shows, things have got out of hand!

VERMICULTURE

India • 13 January 2012

Vermiculture has been around for a long time and is used on many tea plantations. So what is it? Quite simply, it involves raising earthworms by feeding them on a mixture of cow dung and chopped-up leaves. A few weeks later, the earthworm castings are collected and spread onto the soil. The use of this rich compost eliminates the need for fertilizers. In addition, the compost contains worm eggs, which then hatch into worms themselves. Once they've grown into adult worms, they will help aerate the soil and aid irrigation. As well as burrowing tunnels, the worms feed on leaves that have fallen to the ground and speed up their decomposition. Earthworms are a precious asset, providing ongoing benefits for the soil.

With many plantations going organic, it's high time I introduced you to some of the beneficial creatures that live among the tea plants, where the lack of pesticides makes for a quieter life. In terms of insects, there are two categories: those that are detrimental to tea production, and those whose presence is beneficial. As for spiders, some are harmful, while others can be useful. I don't know which category this one falls into, but it is large and unusually elegant. I don't even know its name, so if there are any spider lovers among you, perhaps you could introduce it to us.

ORGANIC PLANTATIONS MAKE GOOD HOMES FOR SPIDERS

India • 8 November 2011

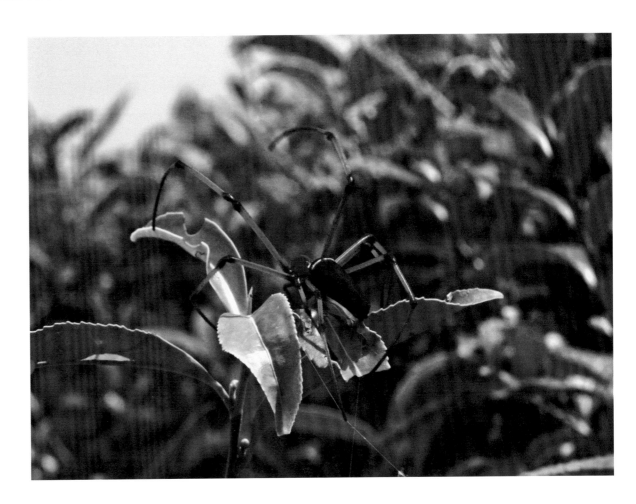

LOOKING FORWARD
TO HOLI

India • 2 March 2012

When I ask planters in Darjeeling when they will begin the first harvests of the year, they always give roughly the same reply: around the time of the Holi festival. Holi takes place in India every year at the beginning of spring. It's the festival of colors. To celebrate, everyone arms themselves with plenty of colored pigments and throws them in the faces of people around them. All day long, they cover their laughing friends—and anyone else they come across—in a riot of colors.

With its coat of bright pink and orange, this elegant creature climbing over a tea bud looks like it has been taking part in Holi. The tea harvest is surely about to start.

A GATHERING OF TEA-PICKERS

India • 18 October 2011

When it's time to take a break, the pickers in Darjeeling gather in the shade to drink tea or eat their meals. We'd all love to be able to have lunch every day in such a peaceful setting.

These shelters are also where the pickers take the leaves to be collected and weighed. Once combined, the leaves are loaded onto a trailer and a tractor promptly tows them away to the factory for processing.

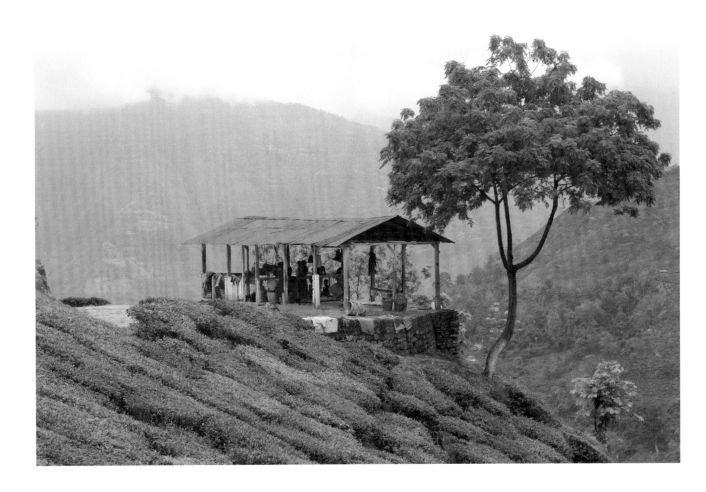

Here, in the south of Sri Lanka, in the region of "low-grown teas," the sun is very intense, and it's best to protect the tea plants from its rays for at least a few hours a day. Curiously, palm trees are used here to provide shade, despite their rarity. As the palm trees themselves are cultivated, this enables the farmer who owns this lovely lakeside plot to harvest two different products on the same land, and both plants benefit.

IN THE SHADE
OF PALM TREES
Sri Lanka • 12 August 2011

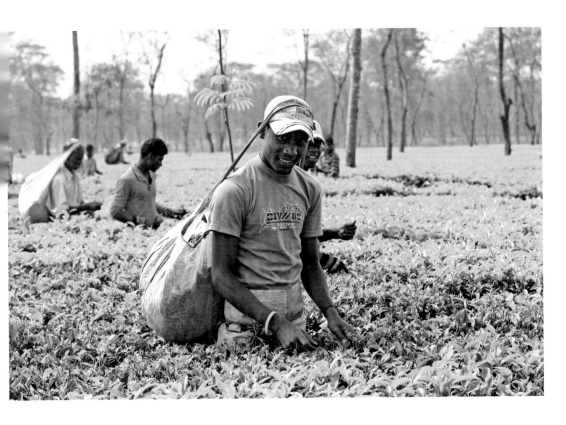

In the Dooars region of India, tea is often harvested by the people known as the Adivasis. Often despised by other Indians because they are right at the bottom of the social ladder, they benefit from positive discrimination, along with the lower castes. They don't get much attention, which is another reason to talk about them here. The Adivasis are one of India's biggest tribal populations. They descend from the aborigines and live in the northeast of the country. I took this photo at Meenglas, near Mal Bazaar, a few kilometers from the border with Bhutan. The Dooars region doesn't produce very good quality tea, but that's not important here. It was the smiling faces of these workers that I wanted to tell you about, not the rather coarse leaves filling their bags.

THE SMILING FACES OF THE ADIVASIS

India • 7 June 2011

TEA PLANTS
PERFECTLY ALIGNED

Japan • 12 November 2010

Just before leaving Japan for China, here's a last glimpse of the landscape shaped by tea. The rows of tea plants are precisely aligned. All is in perfect order, with a few organized clumps here and there, as if to underline the overall harmony. What I love most are the subtle nuances of green, the different shades of the same color, a touch more yellow where the shoots are still young, and a slightly darker green where the leaves have recently been plucked.

TEA NEEDS TLC

India • 2 February 2010

Flowers and seeds are all very well, but they're not enough to make tea, which requires care, patience, observation, and constant attention. It's a bit like love. It's a bit like a blog too: one must look after it every day, smile at it, take pleasure in dedicating one's time to it. Indeed, here is a tea-picker in conversation with the tea plants. She lives just a few hundred meters away and knows every corner of the plot by heart. She knows each tea plant, its strengths and weaknesses. She's concentrating hard and doesn't allow herself to be distracted by the photographer.

AROUND MOUNT FUJI

Japan • 19 February 2010

There are many tea plantations around this Japanese peak, but it's not easy to find a spot where you can only see a tea garden with Mount Fuji in the background. You have to drive around the narrow back roads and repeatedly turn around. It requires patience. And when you reach your goal, don't expect solitude: the Japanese are keen photographers, and there is a real cult attached to their favorite volcano. There were at least a dozen people around me when I took this photo.

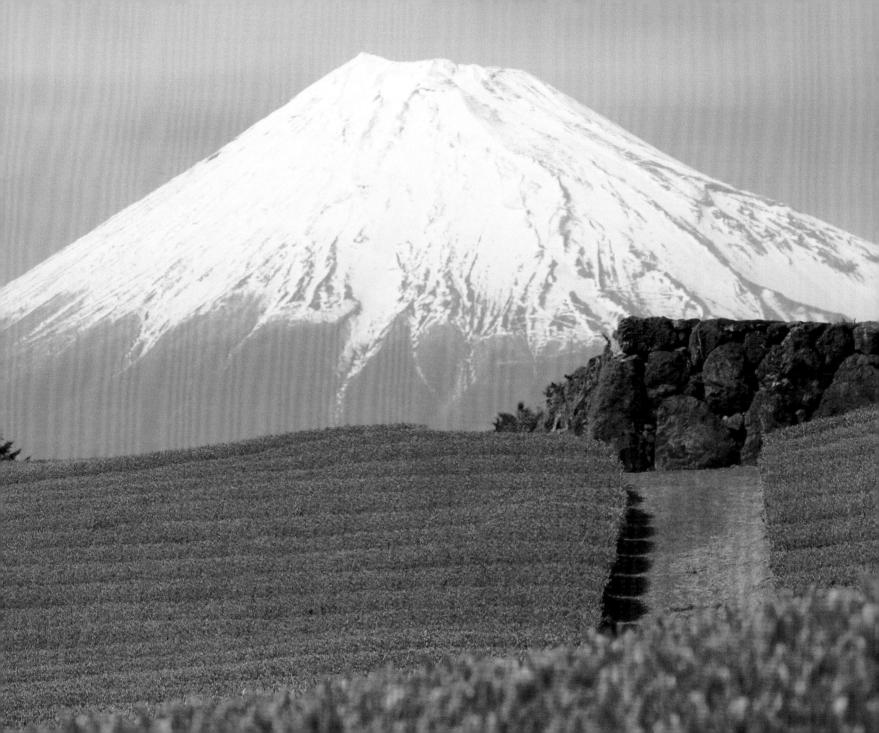

ON HORSEBACK
Nepal • 9 April 2010

In Ilam in Nepal, horses are still used to transport tea leaves. These two young men have walked for two hours to reach the place where the tea is processed, so they can sell their fresh tea leaves. Hanging against the horses' flanks are sacks weighing around twenty kilos each. They try to avoid making this long journey on a rainy day, otherwise the cargo can start to ferment and spoil.

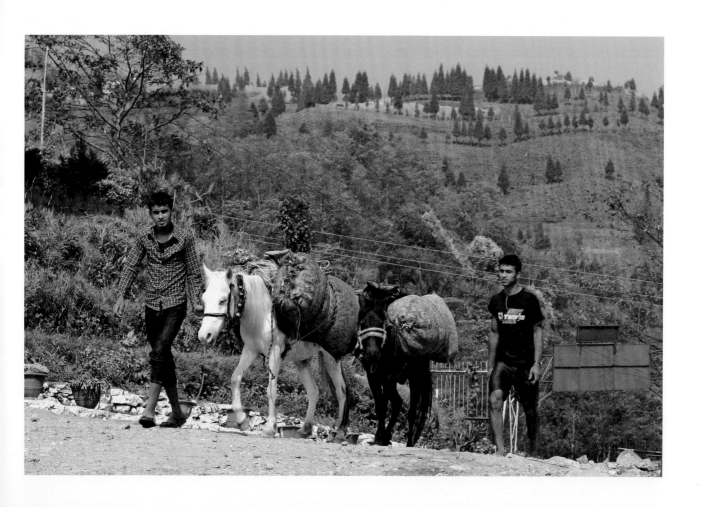

There are a great many cultivars, each with its unique characteristics and qualities. Some are more resistant to the cold, for example, or to certain parasites. Others produce a more abundant crop. Here, in Feng Qing, near Lincang in China, tea planters breed a wide variety of cultivars in order to experiment with grafting, for example, to produce new hybrid tea plants.

CULTIVARS ARE TO TEA WHAT GRAPE VARIETIES ARE TO WINE
China • 23 March 2010

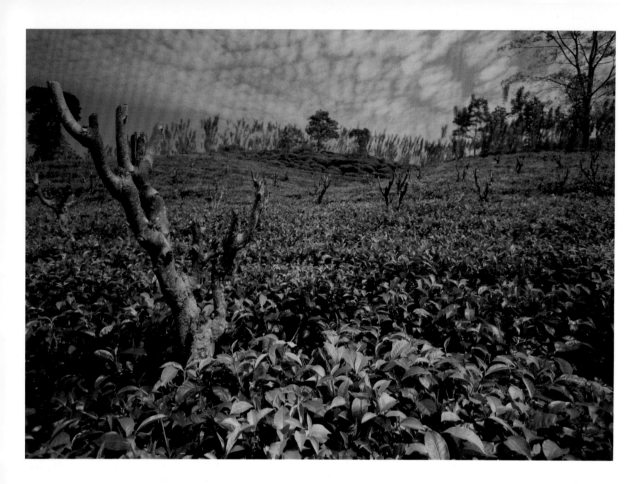

PRUNING TREES TOO
Sri Lanka • 17 September 2010

On a plantation, tea plants are not the only things that need care and attention; the trees do too.

For their foliage to serve a purpose by providing gentle shade for the precious camellias, the trees must be prevented from growing too tall. So from time to time they're pruned back hard, like here near Ivy Hills in Sri Lanka, to concentrate their growth and, most importantly, to keep them low.

116

While all tea plants belong to the *Camellia* family, you'll know that there are different cultivars within that family. Here in Japan, the most commonly grown tea plant is Yabukita. It accounts for 85% of the tea crop, unlike in other tea-producing countries, where many different varieties cohabit.

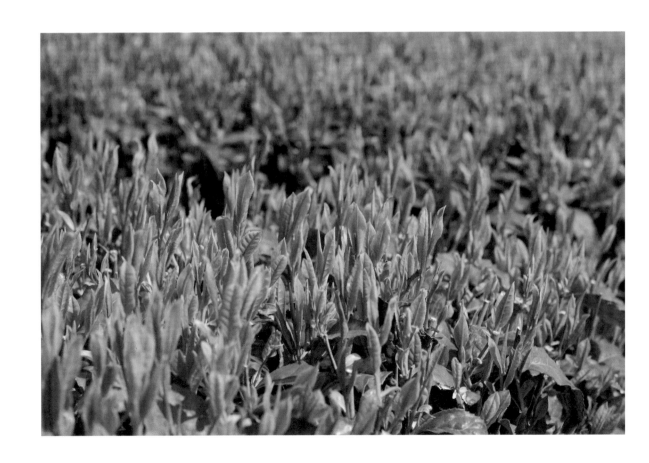 *Yabukita is easy to recognize with its long, straight, deep green leaf. It also has its own way of growing, very upright, reaching up for the sky.*

YABUKITA, THE MOST POPULAR CULTIVAR IN JAPAN

Japan • 9 November 2010

A NURSERY FOR YOUNG TEA PLANTS

China • 9 February 2010

Sometimes you don't even need a seed to produce a tea plant, in fact it's very common not to. Instead, you take cuttings from a carefully chosen parent plant. You remove one tea leaf together with a few centimeters of the shoot and plant the whole thing in compost. The roots form and the shoot grows into a mature tea plant. The covered area where these young shoots grow is called a nursery bed.

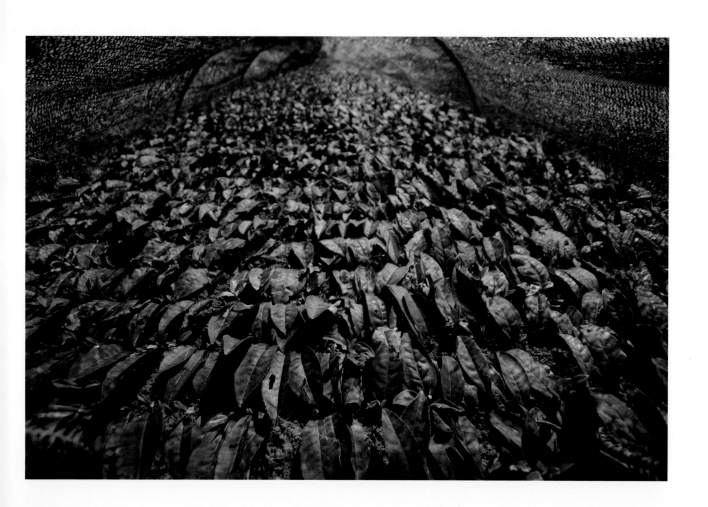

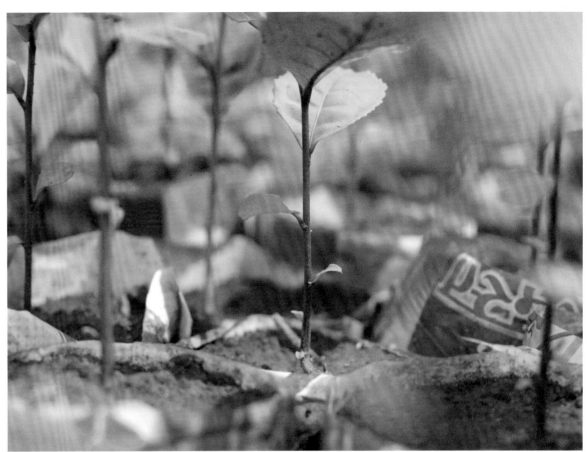

TEA SEEDS

India • 5 February 2010

Once the planter has selected the good seeds, he pushes them into plastic propagating bags filled with soil and fertilizer. He leaves the bags in the shade for two years before transferring the young plants into the ground. A year later, when they're three years old, the tea plants can start to be harvested.

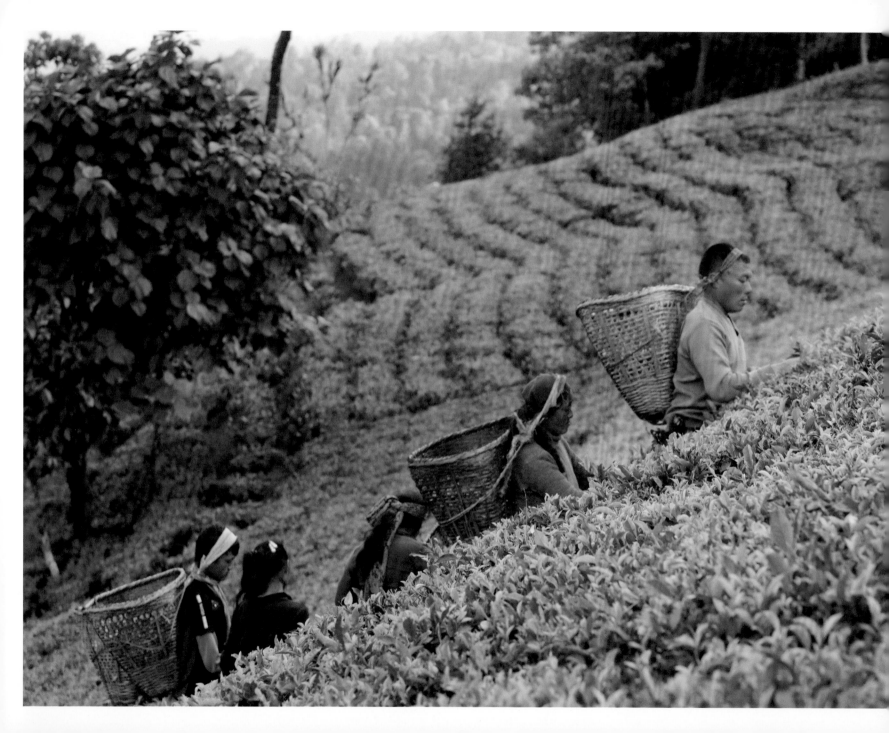

— HARVESTING

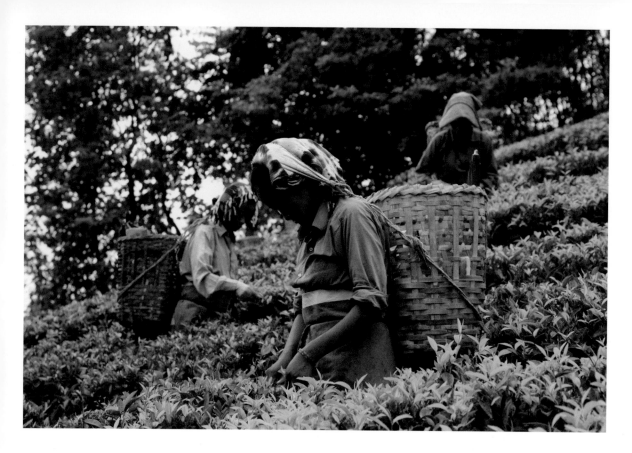

The first Darjeelings of the year are generally described as the "first flush" in English, but in French they're known as the "spring harvest." The latter is misleading as the harvest doesn't fully coincide with the season. There are two reasons for this. Firstly, the low-altitude plantations that use irrigation

"SPRING HARVEST," AN INACCURATE FRENCH NAME

India • 24 May 2019

techniques benefit from more clement weather and sometimes start producing small batches from the end of February. Secondly, leaves on the same shoots are harvested every eight to ten days, and after three successive growths, this thwarting of the shoot's growth leads it to send out a side shoot or *banjhi*, which is of a lower quality and marks the end of the first harvest. This means that the so-called "spring harvests" come to an end around mid-April.

PRECIOUS
SHOOTS
China • 22 July 2016

Wherever it comes from, a premium tea involves rigorous work. This starts with the harvest, which must be done meticulously, and of course continues throughout each stage in the processing. Here, in Anhui in China, they're harvesting Huang Shan Mao Feng—"Downy Tips of the Yellow Mountains." We can see the care taken with the plucking as well as when transporting the leaves, which are shaded from the sun but still have air circulating through them. The baskets are small to prevent any compression of the precious shoots.

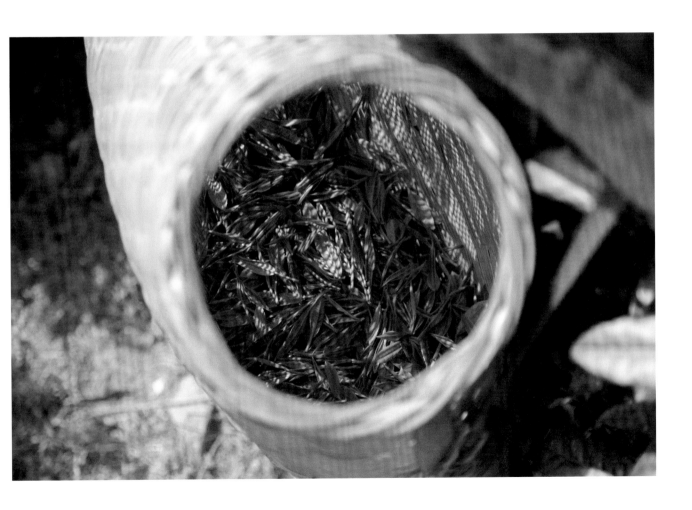

TEA IS NOT ALWAYS HARVESTED BY HAND

India • 15 February 2019

Harvesting tea using shears poses a problem in terms of quality, as the stems get cut too, instead of just the shoot and the two adjacent leaves. For a high-quality tea, nothing surpasses picking by hand. When, during my travels, I see someone using shears, I talk to the planter to find out why this is. Often, it's due to a lack of workers. Another common situation is that the tea is picked by hand in the best season, and then shears are used for the lower-quality harvests: these leaves will be used for tea bags.

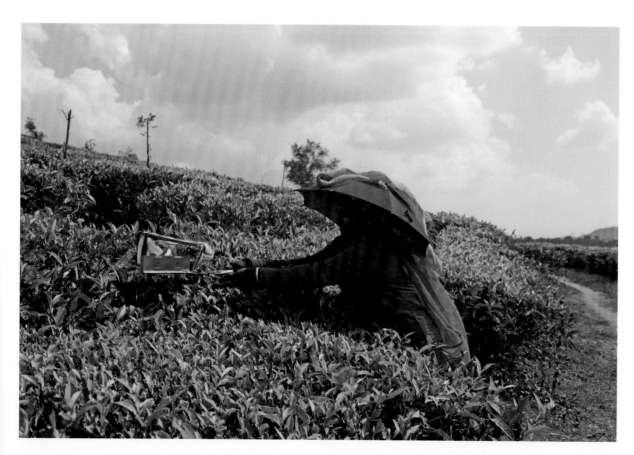

124

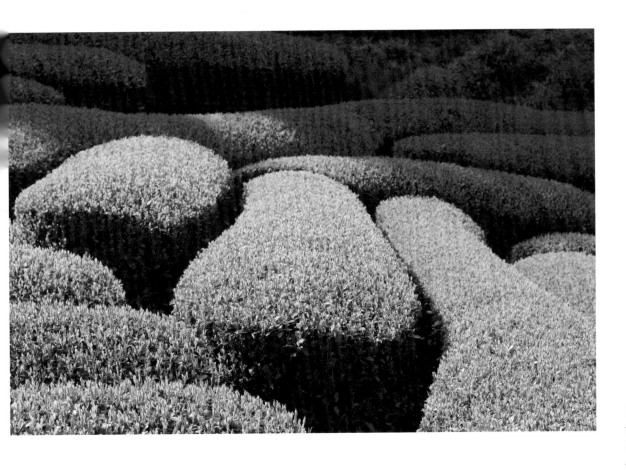

PRECISION MECHANICAL HARVESTING

Japan • 13 July 2018

In most tea-producing countries, tea leaves are harvested by hand. Japan is an exception, the main reason being the high cost of manpower. However, the sophisticated machinery used by Japanese farmers allows them to be very precise when harvesting. Only the young shoots are picked, which are then sorted according to the most rigorous standards in the factory, using machines with electronic eyes.

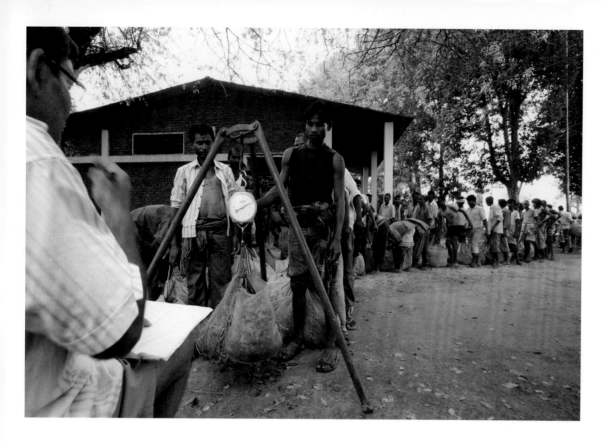

WEIGHING
THE LEAVES
India • 23 September 2011

In the middle of the day, as soon as the picking is finished, the workers gather to get their bags weighed. Here, at Dufflating in Assam, everyone waits in turn and one by one hangs their bag of tea leaves on the mobile scales. The supervisor records the worker's name and the weight of the bag, which will determine the day's pay. You can see that the bags are made of netting, to prevent the leaves from oxidizing. They must remain in perfect condition all the way to the factory, otherwise the tea will be spoilt.

You can tell when the tea leaves are ready for harvesting by the color of the bushes. When the plants take on this yellow-green shade it means the new shoots have reached a good size and it's time to get out your basket and start plucking.

Here, you can see the difference in color between the leaves that have not yet been harvested, in the background, and what remains on the plants after a visit from this Chinese woman, with her agile hands, in the foreground.

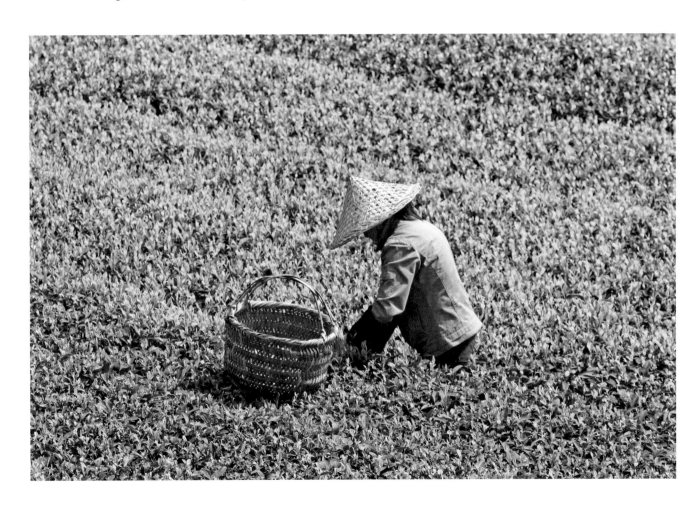

THE FUDING TEA MARKET

China • 26 April 2011

Once harvested, tea spoils quickly. Here, at the Fuding tea market, Mr. Li absolutely must find a buyer in the next two hours. Thanks to the quality of his leaves, he should have no difficulty, and he gives a big smile for the camera.

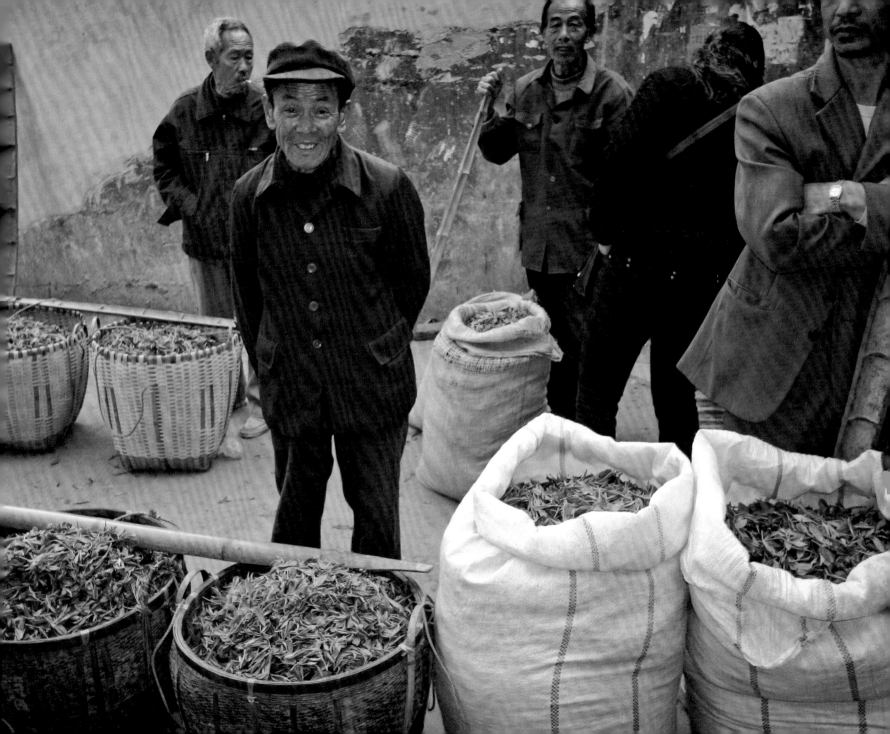

NEW-SEASON GREEN TEAS

China • 19 April 2011

In China, the first tea harvests of the year have begun, and today I'm flying to Beijing, then on to Huang Shan, the magnificent Yellow Mountains.

The best green tea harvests in China take place in April, and Anhui province alone boasts such prestigious teas as Tai Ping Hou Kui, Huang Shan Mao Feng, Huang Shan Mu Dan, and Huang Hua Yun Jian, to name just a few.

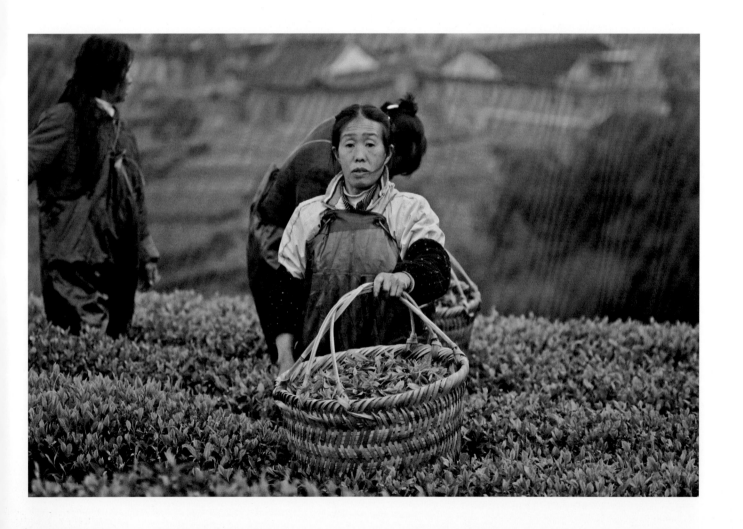

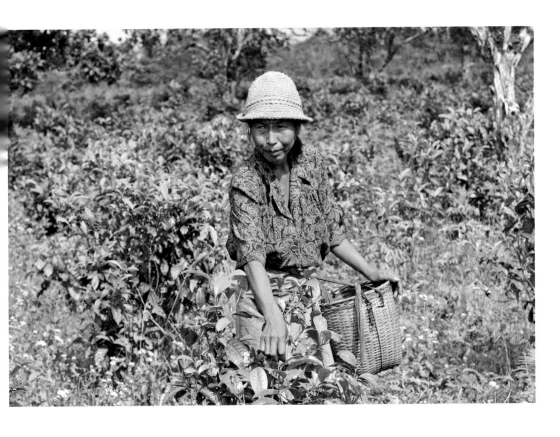

Having traveled around the region where Pu Erh is grown, I moved further south, to Laos. There, halfway between Paksé and Paksong, on the Bolovens Plateau, I discovered a small factory making a very good black tea with aromas of cooked fruits, leather, and spices, which will delight fans of Grand Yunnan Imperial. Curiously, the tea plants here grow in the middle of coffee plantations. In fact, to enable the local rural population, who earn very little, to generate some extra income, the Lao Farmers Association has taught them how to grow tea, and has formed a cooperative with the purpose of supporting the community rather than making a profit.

"LAOS BUDS," A DELICIOUS FAIR-TRADE TEA

Laos • 17 January 2011

As I walked for a few hours among the tea plants and lush vegetation, I noticed two things in particular: the bomb craters left by the Vietnam war, and also the incredible number of leeches you must pull off as you walk. Not only do they climb up your shoes and trousers, but the creatures even manage to drop out of the sky, or rather, the trees, and land all over you, even in the palm of your hand.

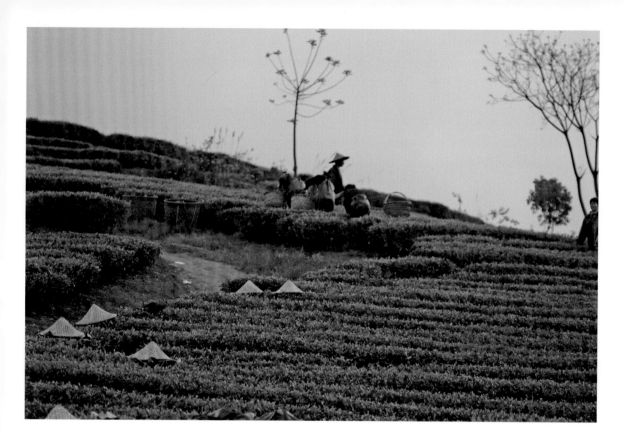

WHERE ARE
THE TEA-PICKERS?

China • 28 December 2010

In eastern China, in Fujian or Zhejiang, for example, tea-pickers wear pointed bamboo hats to protect themselves from the rain and sun. I'd barely had time to set my depth of field when the pickers disappeared to have lunch. They left their lovely headgear in situ. It looked like elves were playing hide-and-seek in the field, with only their little hats visible. I like this photo for its comical element. I'm expecting the hats to lift and reveal grinning faces.

132

The harvesting of leaves to make Pu Erh is interesting. Here, in the west of Yunnan near the border with Myanmar, the tea plants are left in a semi-wild state, and harvesting involves a walk through the forest. Instead of keeping the tea plants cropped at a convenient height for picking, as is usually the case, they're left to grow into trees, or always have been, and the workers walk around them to pluck the bud and the next two leaves, as is the practice with all other teas.

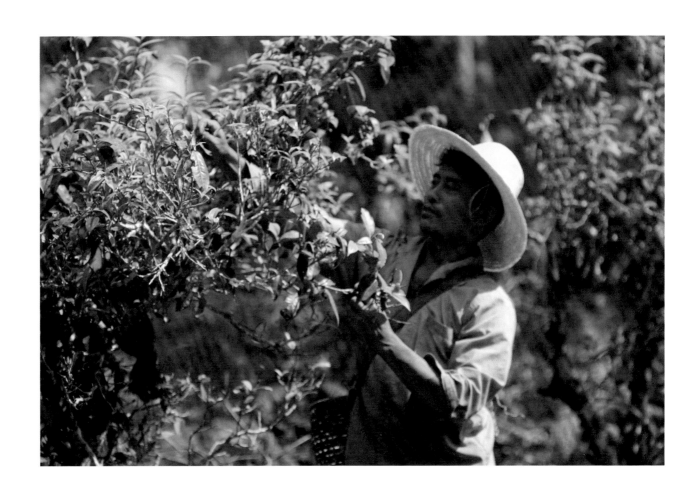

In the middle of summer, a bit of freshness is always welcome. This refreshing mist comes from the foothills of the Himalayas. People there are so used to living in the clouds that the humidity is part of their life and nobody pays any attention to it. It's actually not unpleasant. Just look at the faces of these tea-pickers—they don't seem bothered by it, in fact they look like they're having fun. This is at Badamtam, a magnificent plantation located in the north of Darjeeling, across from Sikkim. A detail: see the umbrella in the basket? It's used when the sun comes out, to provide shade and protect the complexion.

IN THE MIST
OF BADAMTAM
India • 10 August 2010

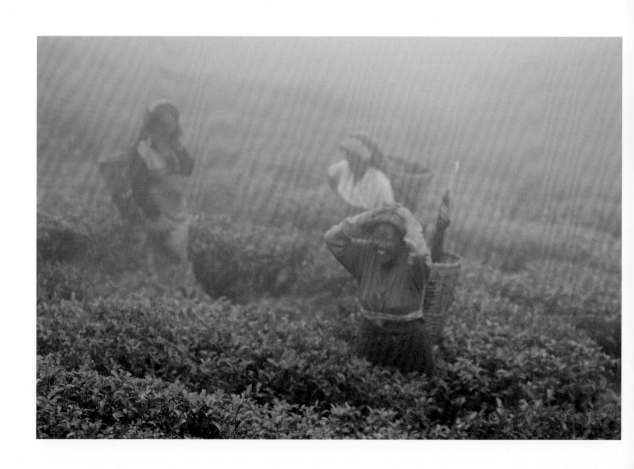

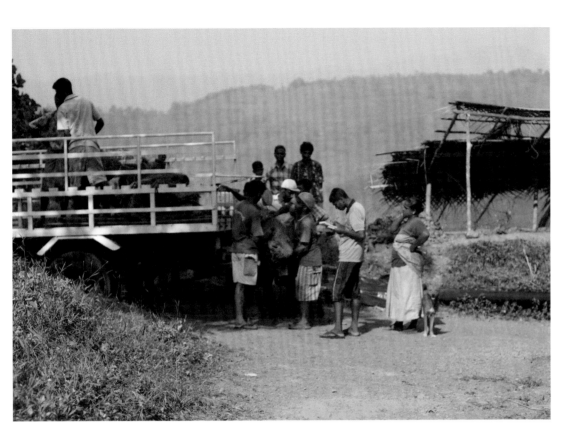

In southern Sri Lanka, tea is mostly grown by individual farmers who cultivate their own land. They sell the leaves after harvesting them, as they don't have the infrastructure to process them. These farmers don't have to go far to find buyers. Their freshly picked tea leaves are in high demand among the local tea factories, which, because of the competition, go to collect the sacks of fresh leaves for themselves.

I spent hours touring the farms in one of these four-wheel-drive pickups. It was an incredible experience: to get the sacks we sometimes had to go right up into the mountains, skidding on steep tracks, driving alongside vertiginous drops or through forests ringing with a chorus of monkey cries, then suddenly we'd find ourselves on the mountain top, with farmers who rear their own animals and grow various crops to sustain themselves, far from anywhere.

We'd buy the tea leaves, chat for a while, and sometimes drink tea together. We'd talk. We'd laugh. Then it would be time to go, to collect yet more sacks of tea from other isolated farms.

ON THE ROAD
WITH TEA LEAVES
Sri Lanka • 30 July 2010

WITH THE AID OF
BAMBOO STICKS

India • 20 April 2010

When harvesting tea leaves, you must take great care to pick the right parts. Only the bud and the two adjacent leaves produce quality tea. Sometimes, to prevent the pickers from taking too much off, they're given a short piece of bamboo. This helps them pluck just the right length of shoot and is a reminder of the standards of excellence required, like here at the Namring Tea Estate in Darjeeling, in India.

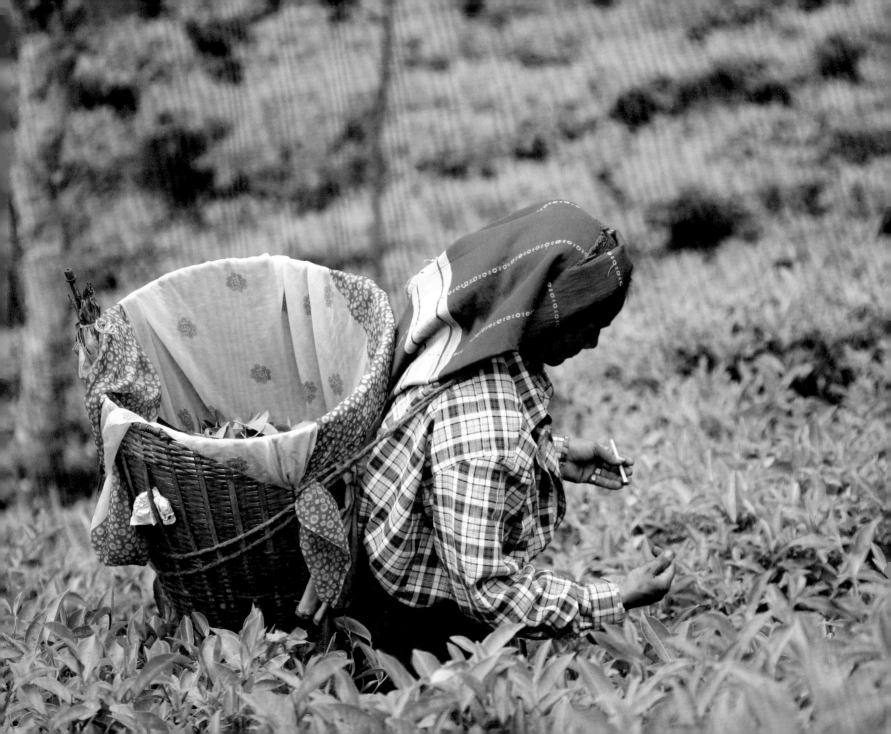

A TEA MISSIONARY
Nepal • 16 July 2010

On the Terai plain that straddles Nepal and India, I've seen people use strange crosses to mark the height of tea plants. The cross is stuck into the ground and only the shoots growing above the horizontal bar are picked. It makes this cheerful worker look a bit like a tea missionary.

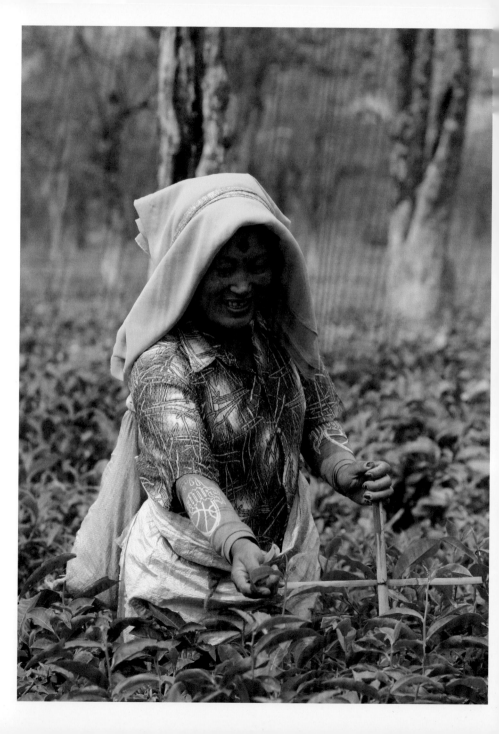

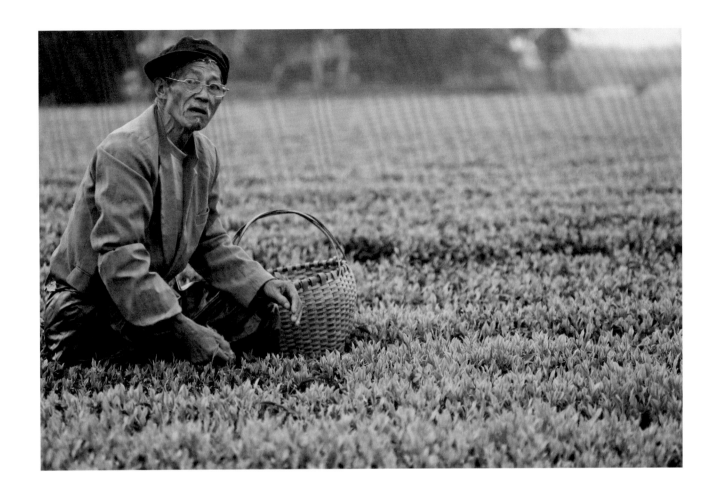

PROTECTIVE SLEEVES
China • 25 June 2010

In different regions of the world, people who harvest tea wear protective sleeves over their clothes. Camellia is quite a tough bush and it can quickly leave the workers' clothes in tatters. This Chinese man, who I caught with my camera hard at work, wouldn't disagree.

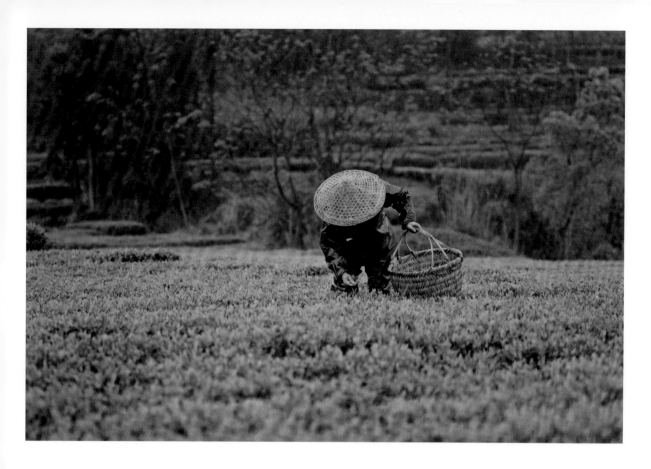

AT THE RIGHT HEIGHT

China • 6 April 2010

Because the leaves are picked constantly, like here in the Chinese region of Gao Shan, which literally means "High Mountain," the tea plant can't grow any bigger. Harvest after harvest, it's maintained at the right height: not too low, so the task isn't made more difficult, and not too high, to stop parasites developing at the base of the plants. The bushes are kept between knee and waist height, depending on the region and the climate.

Did you know that tea plants sometimes need covering? This only happens in Japan, where there are two categories of tea: "sun-grown" and "shade-grown". The sun-grown teas (Sencha, Bancha, Tamaryokucha) are harvested and processed from bushes exposed to sunlight, whereas shade-grown teas (Gyokuro, Kabuse, Tencha) come from plants that grow in the shade, or even in darkness. This stresses the plants, which respond by taking up more nutrients from the soil. This unusual treatment results in a well-developed, smooth and full flavor (which the Japanese call *umami*) without any bitterness. In other words, a delight. I took this photo near Nara. I was attracted by these neat rows of tea plants covered with a silvery black canvas, glimmering in the sun. I stopped to look at them, fascinated by their dark brightness, as you might stop in the moonlight to gaze up at the stars.

TEA PLANTS UNDER CANVAS
Japan • 25 May 2010

MECHANIZED HARVESTING
IN SHIZUOKA REGION
Japan • 18 May 2010

In Japan, tea harvesting is highly mechanized. In the Shizuoka region, which is on the Makinohara Plateau, where Sencha teas are produced, you come across some machines that talk to the leaves in an odd way. And yet these sharp, deft steel fingers don't harm them. With extreme precision, this strange picker takes only the most tender parts of the shoots.

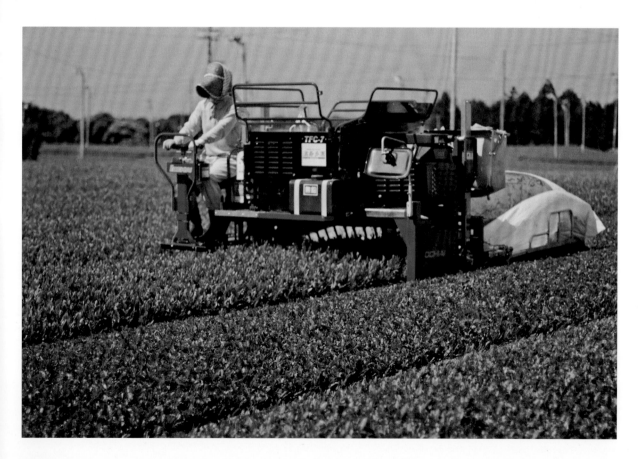

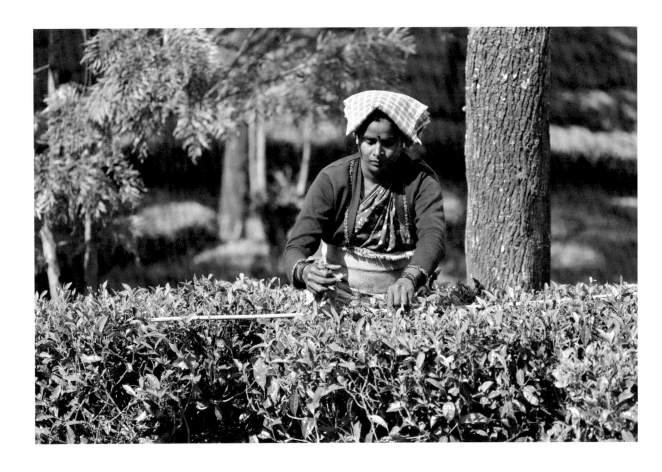

On some tea plantations, workers use a long bamboo stick to ensure a quality harvest. This photo, taken in the Nilgiri mountains in India, shows how it is used: the picker has placed it in front of her and only takes the shoots that extend above it. This prevents her from picking the previous season's leaves, which are tougher and don't produce good tea.

A CLEVER TRICK TO ENSURE A QUALITY TEA HARVEST

India • 24 April 2010

— PROCESSING

A BETTER WAY TO SMOKE
China • 24 October 2019

Smoked tea, or Lapsang Souchong, is a specialty of Fujian. It's not very popular with Chinese people, so it's exported. European food safety regulations were tightened a few years ago, and it's now very difficult to find a smoked tea that meets those standards. This isn't due to specific pesticides, but because of a molecule called anthraquinone that forms naturally during the smoking process. For several years, I've been encouraging a number of farmers to modify their smoking technique so that their tea can be approved. It's a slow, ongoing process, but there have been some positive results.

Black teas are oxidized; green teas are not: that's the difference. With Oolongs, it's more complicated. They can be oxidized a little, a lot, or zealously. Their oxidation rate can range from 10% to 70%. Of course, a lightly oxidized Oolong will have a more vegetal aroma, while a more oxidized Oolong will develop woody, fruity notes. Whatever the level of oxidation required, the processing steps are the same: withering, sweating, roasting, rolling, then drying. The sweating stage is essential. It involves alternating periods of stirring the leaves with periods of resting them, as illustrated by this photo. The aim of this stage is to encourage oxidation while removing the natural moisture from the leaves.

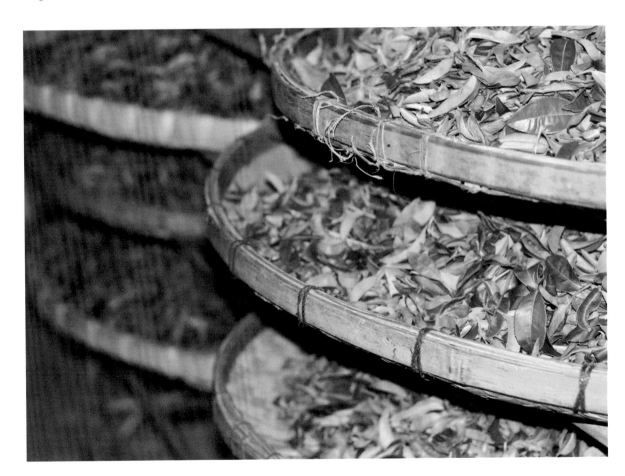

THE ART OF MAKING JASMINE TEA

China • 5 October 2018

The world's finest jasmine teas are produced in August and September in Fujian province in China. They're made using a green tea base, and as the best green teas are harvested in April, the required quantity is reserved at the time. The jasmine flowers, on the other hand, are picked at the end of summer. Jasmine flowers open in the evening, when they release their fragrance. When this happens, they're placed in layers with the tea leaves, impregnating them with their heady scent. Throughout the night they're mixed together to ensure the leaves absorb as much of the fragrance as possible. When day breaks, they're separated, before the jasmine flowers turn bitter.

In the past, Pu Erh cakes were compressed by hand using a large stone with a handle and a convex underside to weigh down the leaves. Today, this task is carried out in a similar manner. Once the tea leaves have been steamed, they're wrapped tightly in a cloth. They're then compressed mechanically, as you can see in this photo taken in a suburb of Kunming, at the Gu Dao Yuan Tea Factory.

MECHANICAL COMPRESSION OF PU ERH CAKES

China • 3 December 2010

149

A FARM ON A HUMAN SCALE

Nepal • 6 July 2018

Some teas are produced on a vast estate with up to a thousand people living on it. Some are produced by a cooperative of small producers. And some are produced on a simple farm, like here, at Pathivara. Different farms have different social structures, and I prefer the ones on a human scale. They're a far cry from the cliché of the planter living cut off from the world in a magnificent bungalow (inherited from the days of British rule). When tea is produced on a farm, the villagers often spend the evening there too. They sit around together, chatting endlessly. Sometimes they drink, sometimes they play music, sometimes they dance. It's life, quite simply.

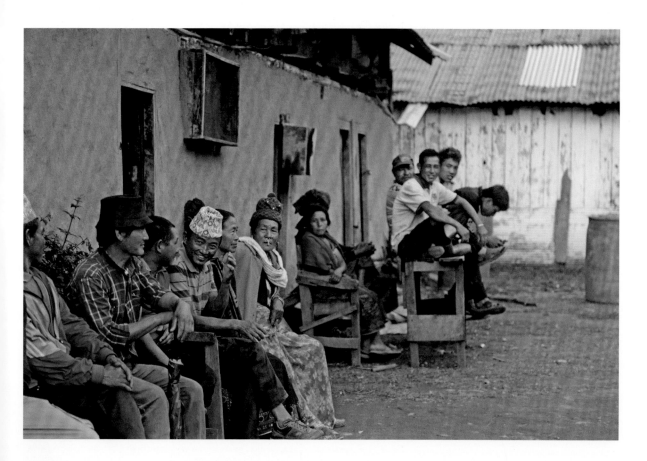

What possible connection could there be between these tattered old cloths and tea? Simple: these thick rags are used to cover piles of tea leaves, keeping the oxygen out. In that damp, dark environment, the tea will ferment. This is a crucial step in processing cooked Pu Erhs. Every day, someone will check the temperature of the leaves, letting in a bit of air if they get too warm. They will also dampen the leaves several times over the forty days or so of ripening, covering them again immediately each time.

In the cup, cooked Pu Erhs develop notes of wood, undergrowth, caves, damp earth, straw, humus, leather, and licorice. It makes me smile to think that these cloths in shades of brown create the same sense of autumn as the aromatic bouquet of the teas they cover.

COOKED PU ERHS, AN AUTUMNAL PALETTE

China • 29 September 2017

151

A VERY SIMPLE TEA

China • 29 July 2016

The most artisanal way of producing tea can be seen here and is very simple. I was honored to be a guest of a man from the Dao ethnic group, who makes his tea at home. He throws fresh tea leaves onto the sides of a wok heated over a very hot fire. He shakes them constantly to dry them out and shape them, never letting them burn. It's a rudimentary method commonly used by people who live in tea-growing regions.

In the cup, the liquid is fairly rough, powerful and quite astringent, and retains some of the smell of the fire. It wakes you up and epitomizes the simplicity and generosity of this rural hospitality, reminding you what life is really about.

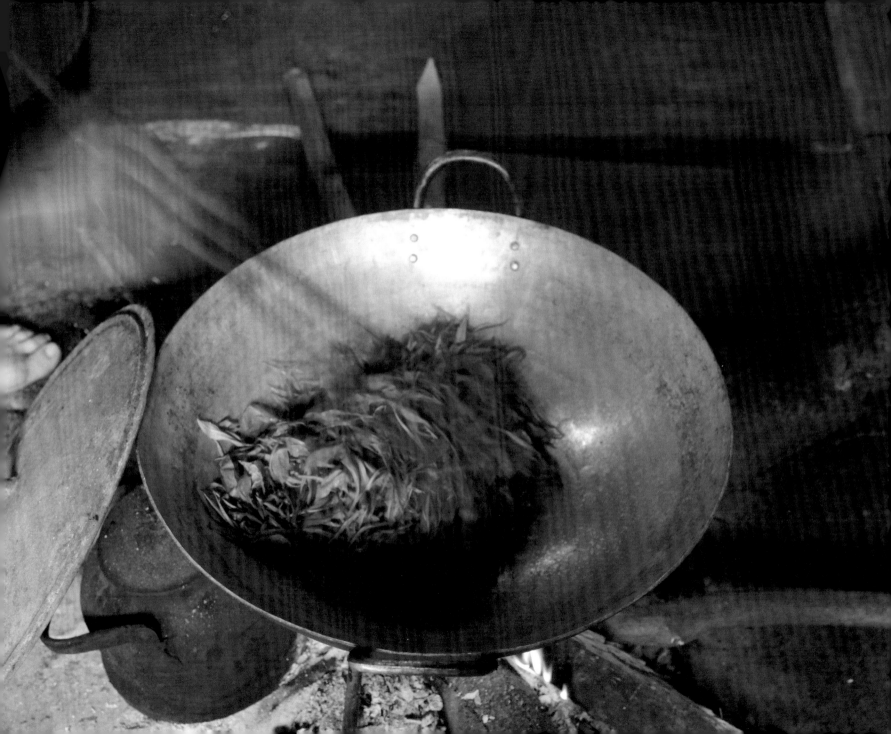

The buildings in which tea is processed are full of smells. Withering produces the most pronounced aromas, giving off vegetal, floral bouquets. The smell is so powerful, it literally transports you.

However, if you visit a tea factory outside the production season, like here at the Palampur cooperative in India, other aromas are more dominant. You find yourself shutting your eyes to appreciate the powerful smell of straw and horsehair.

THE SMELL OF TEA FACTORIES
India • 4 December 2012

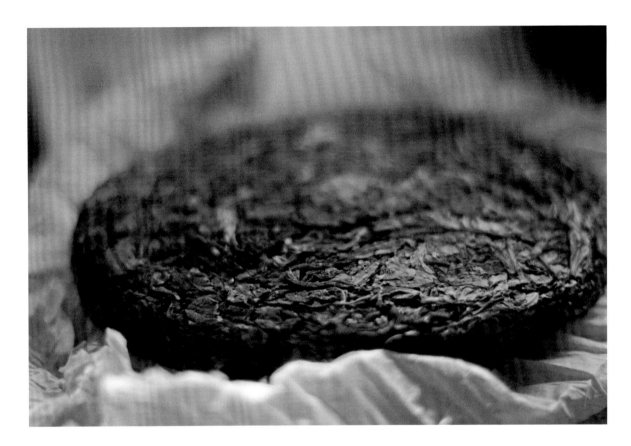

2007 saw the start of a spectacular craze for Pu Erh in China. In the space of a few weeks, this previously barely known tea became the subject of frenzied speculation, and it took two or three years before prices came down again. Now it seems this same phenomenon is about to be repeated. Once again, the Chinese are queuing up to buy cakes of this tea, which is said to improve with age. As before, the cause is speculation. At the Canton Tea Fair, which has just taken place, we saw Pu Erh cakes selling for over €1,000 each.

HIGHLY PRIZED PU ERH CAKES
China • 29 November 2013

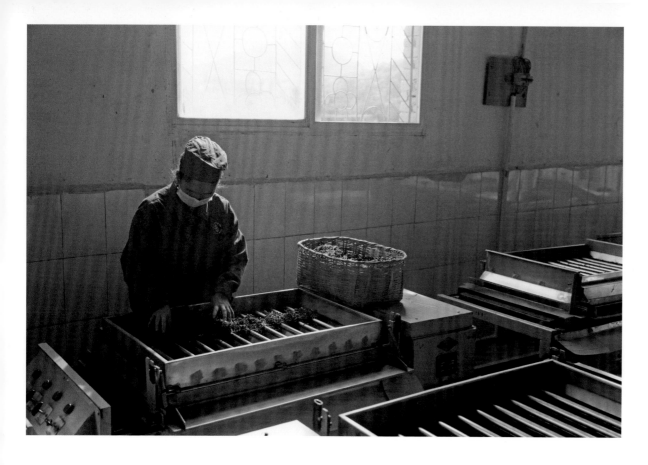

ROLLING MAO CHA
China • 8 September 2017

Mao Cha—the raw tea from which Pu Erh is made—increasingly undergoes a rolling stage. Right after the leaves have been withered, then heated in a wok, they're placed in a machine that shakes them from side to side, rapidly and regularly. As the leaves hit the vertical sides, their shape gradually changes, and they curl up gently lengthwise. Rolling takes place with most teas; it shapes the leaves. With green teas, for example, it breaks down the cells and releases the aroma compounds that oxidize or ferment.

THE CAPTIVATING AROMA
OF WITHERING LEAVES

India • 10 November 2011

Withering tea leaves can take dozens of hours, during which time the leaves will lose some of their water content. In order to avoid the risk of oxidation, hot or cold air is sometimes blown under the leaves. At this point, the air fills with a wonderful fragrance, very typical and floral, which can be detected for hundreds of meters around. I never grow tired of this smell. I find it captivating.

LEAF BY LEAF

Nepal • 3 April 2015

It's difficult to comprehend what tea processing involves in terms of expertise and refinement. Here, for example, the production process has been completed, and this woman is going through the leaves one by one to remove tiny stems and other imperfections.

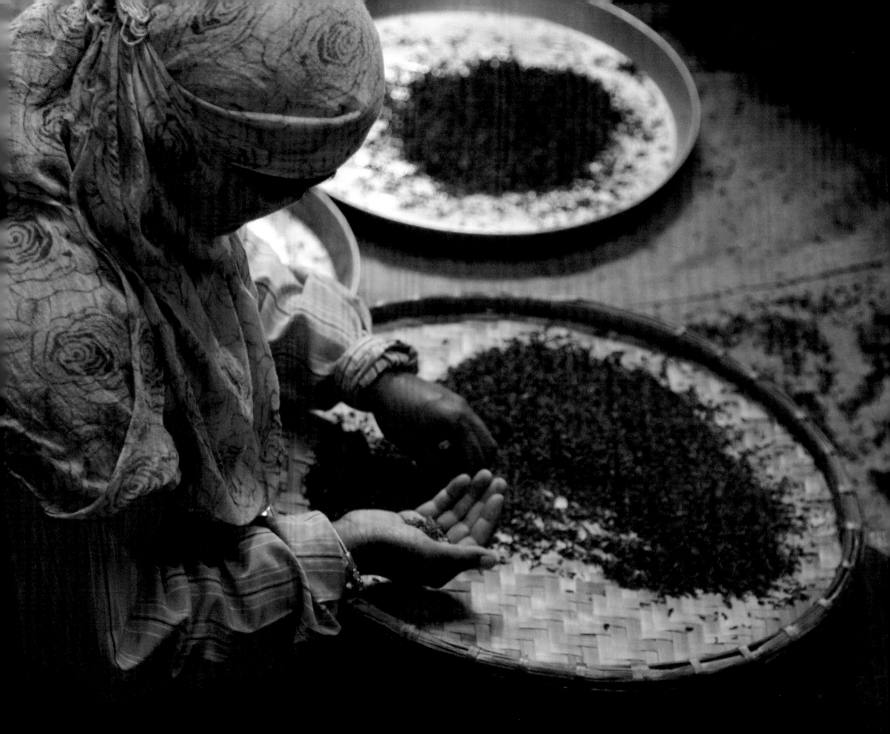

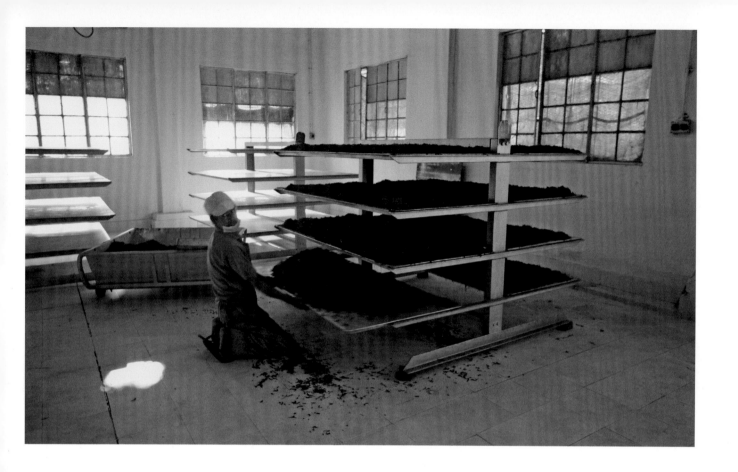

TEA OXIDATION

India • 26 October 2012

Oxidation is an important stage in the process of making black tea. It's not very easy to photograph as it consists of spreading out the tea on sheets in a fairly warm and humid atmosphere, then simply waiting for time to pass.

HEATING LEAVES IN A WOK

China • 22 June 2012

Here, near Hangzhou in China, tea leaves are being processed on the scorching sides of the wok. The leaves are heated before being shaped as required, then dried. They must be processed quickly and precisely, which is why many farmers prefer to work with their bare hands.

AS FAR AS THE EYE CAN SEE

India • 30 August 2011

I took this photo at night, and the dim light adds to the mystery of this essential stage in tea processing. During the withering stage, the leaves will lose much of their water content.

THE ART OF MAKING TAIPING HOU KUI

China • 6 May 2011

Taiping Hou Kui is harvested for just twenty-five days a year, generally between 20 April and 15 May. For the rest of the year, the tea plant can grow without having its leaves plucked. This concentrates the harvest in the best season. Mrs. Zha has a pretty plot of land on the edge of Lake Taiping. She's very busy at harvest time. Taiping Hou Kui is one of the most expensive teas in China, and its price can reach thousands of yuan per kilo.

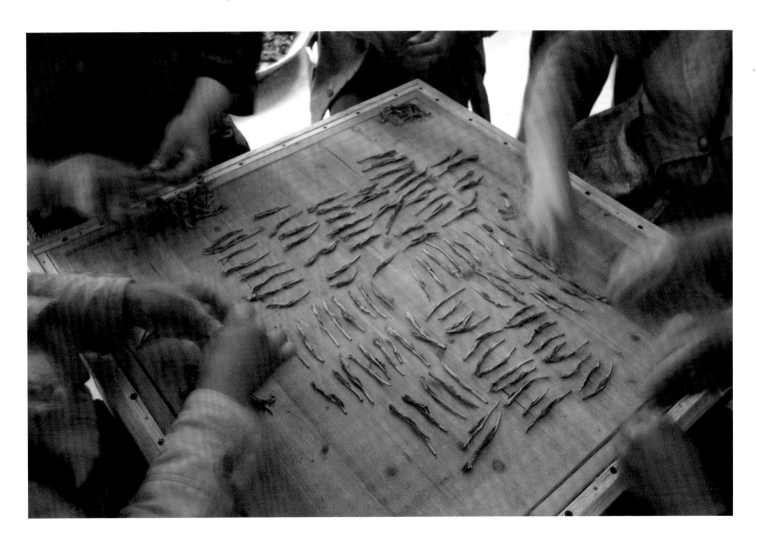

MATCHA GROUND
IN A STONE MILL

Japan • 15 February 2011

In Japan, a special tea is served during the Cha No Yu, the famous tea ceremony. It's called Matcha. Matcha differs in appearance from other Japanese teas in that it's ground into a powder. In any other tea-producing country, tea that comes in broken leaf or dust form would be a sign of poor quality, but in Japan, Matcha is one of the most renowned teas due to its high quality. It comes from a shade-grown variety of plant called Tencha. The leaves are ground in a stone mill that is filled from the top. The result is this very fine powder which, as you can see from the photo, collects around the edge of the two stones that rotate across each other and push the tea to the outside.

THE TEA
IS IN THE BAG
Sri Lanka • 23 July 2010

A beautiful warm evening light illuminates these sacks made from thick string, filled with fresh leaves, in Dellawa, Sri Lanka. A few minutes later, the leaves were taken to the top floor of the tea factory to undergo the first stage of processing: withering. This stage can take up to twenty hours for this type of black tea. It consists simply of spreading out the fresh leaves thinly in long, well-ventilated trays, and leaving them to reduce their water content.

STEAMING PU ERH CAKES

Traditionally, Pu Erh tea is sold in "cake" form, each one weighing 12 ounces (357 grams). Here, you can see the first stage in the processing: the woman weighs out the tea to the nearest gram, then tips the exact quantity into a metal cylinder with a perforated base, which she places above a source of steam. On contact with the steam, the tea leaves soften and are then ready to be compressed.

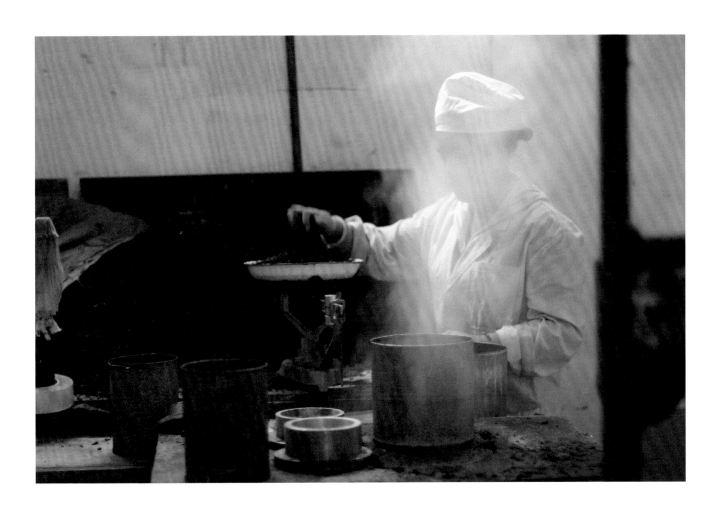

— TASTING

ALL MY FAVORITE TEAS

India • 20 September 2019

I'm often asked what my favorite tea is, and the question always makes me nervous. Each time I have to think about what to say. Someone who doesn't know much about tea might say they like a certain type of tea, and someone else might name a different type. But when you have the incredible and very good fortune to taste the best teas in the world throughout the year, like a top sommelier drinking wine, how is it possible to name just one? When you've tasted so many teas of each type, they become part of you. You get to know them from every angle, you discover their unique characteristics, their point of equilibrium, their harmony. You're in the best position to appreciate them. This applies whether it's a lightly oxidized Taiwanese Oolong, a first-flush Darjeeling, an Oriental Beauty, a Japanese Ichibancha, a new-season Chinese green tea, a hand-rolled Nepalese tea, a black Chinese tea such as a Qimen or a Yunnan, a Rock tea or a Phoenix tea, a dark tea from China, Africa or elsewhere, a Mao Cha plucked from hundred-year-old trees, or a Gao Shan Cha, to name just a few. You're the best placed to appreciate them, and the worst placed to pick just one. So if you meet me, please be kind and don't ask me to name my favorite tea. Instead, ask me what I love about this tea, or that tea, ask me about the feelings they evoke. Talk to me about the rich variety of sensory and emotional responses instead of restricting me to a few.

THE RIGHT INFUSION TEMPERATURE

Myanmar • 4 October 2019

When you're traveling, you sometimes have to boil water to purify it. For tea, that's obviously not ideal, especially as some teas need to be infused at 120°, 160°, or 180°F (50°, 70°, or 80°C).

🍃 *Here's a simple method to reach the correct water temperature for your tea (this will be marked on the packaging of any decent tea merchant). When your water has boiled, pour it into a receptacle. The water temperature will drop by nine degrees. Then pour it into another; it will drop by nine degrees again. And so on.*

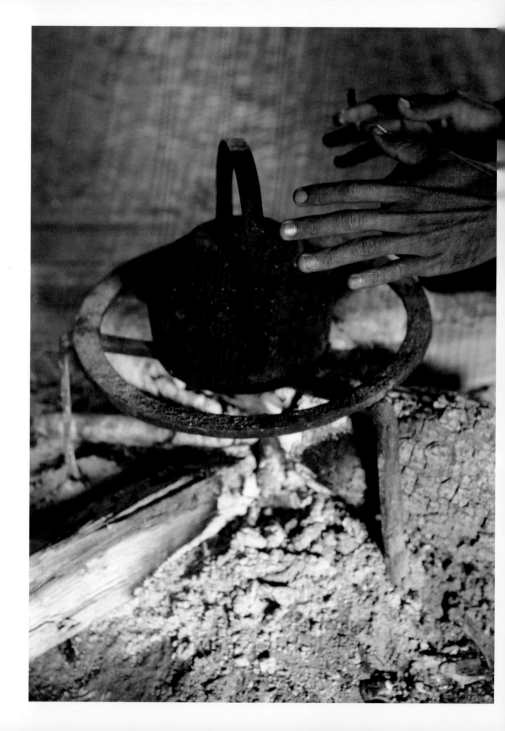

EGGS WITH TEA

France • 19 April 2019

If you've never cooked with tea, here's a simple recipe to get you started: marbled eggs. With Easter approaching, although we're not talking about chocolate, we're staying with the theme. And of course, you can still hide them for an Easter egg hunt for added fun!

Hard-boil your eggs, then place them in cold water. Gently crack the shell by tapping the egg lightly on all sides. Next, place the eggs into simmering water for 20 minutes along with ½oz/15g of Pu Erh Imperial (per 1¼ cups water/300ml), a stick of cinnamon, a tablespoon of soy sauce, two star anise and a pinch of salt. Then leave to cool. They can be kept, unpeeled, in the fridge for up to 48 hours.

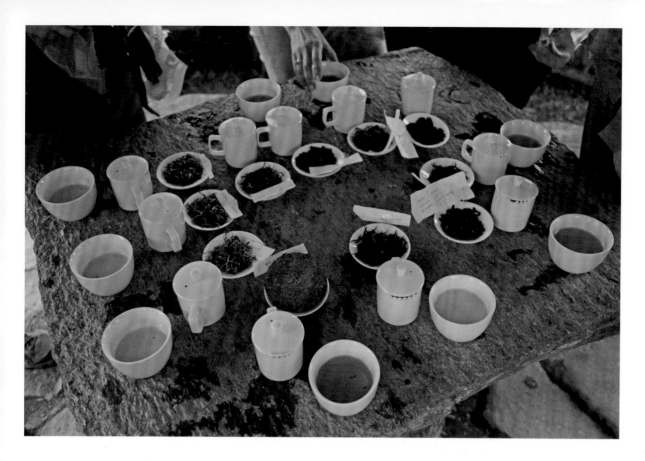

TASTING TEA OUTDOORS

Nepal • 17 May 2019

A visit to a tea plantation always includes a tasting. This one took place in the dedicated tasting room, with light coming in from outside. Sometimes though, tastings can take place outdoors if the factory is too small or doesn't have the right equipment. With a bit of luck, you can enjoy magnificent scenery while swirling the liquid around in your mouth. Here, in Pathivara in Nepal, a lovely stone table is used for tastings.

174

TEA YOU CAN EAT

Myanmar • 13 September 2019

Tea isn't only consumed as a drink; it can be eaten too. In Myanmar, for example, *lahpet*, or *lahpet thoke*, is a national dish. It's a salad made from fermented tea leaves to which are added vegetables, fruit, meat or dried shrimp, for example, as well as spices. It's delicious!

— TASTING

The preparation for a tasting is a special moment. I watch what my host is doing, every precise movement. The leaves are presented on a surface that allows you to see them, then the tea is weighed out to the nearest tenth of a gram before being steeped for a specific time. Each tea must be brewed in exactly the same conditions. Before tasting the tea, while the liquids cool a little, I like to take a few photos of the room itself, of people going about their activities, their faces, or the landscape. I often make use of windows. The reflections can be unexpected. I take photos through the window while others look on, perplexed. Here, at the Kanchenjunga Tea Estate, through the grille-covered window, you can see the tea being prepared against a backdrop of mountains and the tea garden.

WAITING FOR
THE TEA-TASTING TO BEGIN
Nepal • 9 June 2017

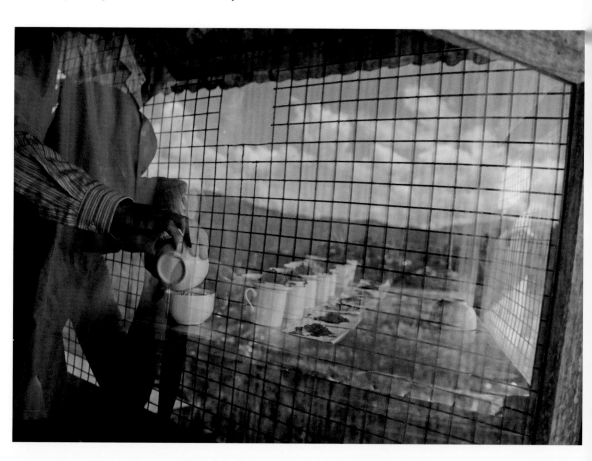

FLAVORS OF TEA
India • 16 August 2019

When we eat or drink something, we pay attention to its appearance and color, of course, but once it's in our mouth, we consider the flavor, texture, and aroma.

🍃 *There are five flavors, or taste elements: sweet, salty, sour, bitter, and a fifth, lesser known taste, called* umami. *Tea doesn't naturally have a salty flavor, but all the other taste elements are present. A tea can have several flavors. Just as an orange is both sweet and sour, a Pu Erh can be both sweet and umami.*

First-flush teas are often the best, being the year's first harvest. Although winter is drawing to a close, the nights are still cold, which keeps the plants growing slowly, resulting in richer flavors. Every year, Darjeeling starts the season, ahead of Nepal, China or Japan.

In March, I sometimes taste nearly a hundred teas a day, as each of the eighty-seven tea estates in Darjeeling manufacture very small batches, some-times no more than twenty or thirty kilos. In this region, during the period when the highest quality of tea is produced, one day's harvest is never mixed with the next. The result is a stream of very different tastings. Buyers snap up the best batches in a matter of hours, at premium prices, which is why it's so important to know every producer and maintain the best possible relationship with each of them.

DARJEELING STARTS THE SEASON

India • 15 March 2019

THROWING CUPS
IN KOLKATA

India • 8 April 2011

In Kolkata, as in many Indian cities, people drink tea everywhere, especially in the street. There are many tea shops, where you drink chai standing or perched on the end of the single wooden bench on the pavement outside. In the tea shops, tea is generally served in freshly fired clay cups, which are very porous. When you've finished drinking, you throw your cup on the ground, and it breaks. As the day goes on, a little heap of broken cups gradually forms.

SIMPLICITY

India • 1 November 2013

There are many ways to make tea and to drink it. Some cere-
monies must be learnt, like the Japanese Cha No Yu. Other
rituals have rules that are no less specific, like the British,
Chinese, Moroccan, Tibetan, and Russian customs, and
many others. But we should never forget that for a quarter of
the inhabitants of our planet, tea is the simplest drink there
is. It's consumed without fanfare, anywhere, at any time
of day or night; it is the most obvious
thing in the world, both delicious and
comforting; it's served in the street; it's
tea, plain and simple.

ANALYZING
THE WET LEAVES

Nepal • 28 July 2017

When we taste tea, we pay atten-
tion to the leaves at every stage. Of
course, we're interested in the liquid,
which we drink, but we also examine
the dried leaves. Are they whole or
broken? Do they contain buds? What
color are the leaves? Are they all sim-
ilar? Lastly, the infused leaves can tell
us a great deal. We smell them, and
press them, as Nirananda Acharya,
the manager of Kanchenjunga Tea

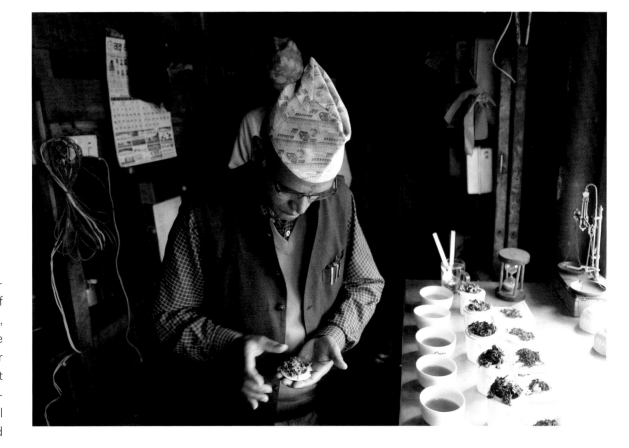

Estate, is doing here. Often, smelling the wet leaves can tell us
as much about the tea as drinking the liquid itself. The wet leaves
inform us about every stage of the processing. We can pick up
on the slightest defect, or on the contrary, we can revel in the
wonderful bouquet.

CHAI IS GREAT!

India • 6 May 2016

You know what tea drinkers are like—they can be obsessive. They save a special teapot for a particular tea, they infuse some teas for exactly three minutes and forty-five seconds in water at 185°F (85°C), others for just two minutes in water at a maximum temperature of 140°F (60°C).

So, this photo I took in Kolkata makes me smile. Firstly, because I really enjoy drinking chai when I'm in India. Secondly, because all the tea drinker's principles have gone out of the window here. This chai wallah boils up his water, puts milk in his tea, adds a load of spices and works in basic conditions, seated on a scrap of cardboard placed on the pavement, without fanfare. And that's what tea is about, too: simply made, with care, and an absolutely delicious drink in a cup.

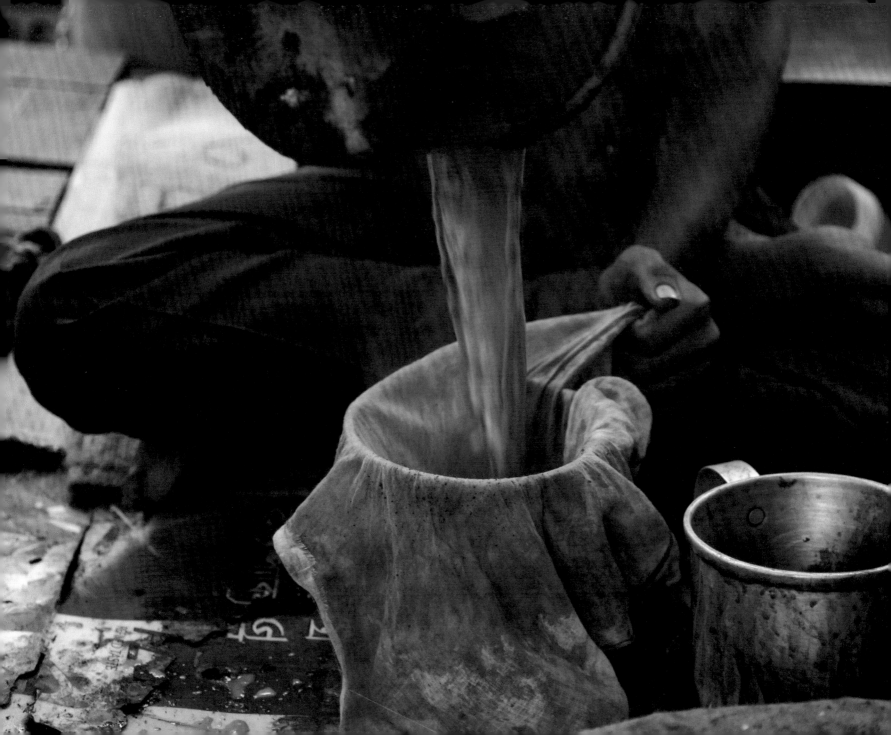

THE TEA PET, THE TEA ENTHUSIAST'S BEST FRIEND

China • 17 March 2017

Pets are wonderful creatures that can show the greatest humanity at times when our fellow humans may be lacking. We find these companions to be so sensitive and loyal that the description of animal doesn't do them justice.

In China, all tea connoisseurs and enthusiasts who use the Gong Fu Cha to prepare their brew have one or more tea pets. The tea pet is a terra-cotta figurine placed on the tea boat, over which tea is poured from time to time, to share special moments with it. Over the years, the figurine acquires a patina through repeated dousing. The tea pet can be an animal or a human figure, as seen here. A tea pet shares your day-to-day life. Like other pets, it's always in an agreeable mood and is good at listening. You know where to find it. It's always there for you, loyal and happy.

A TEA RICH IN ANTIOXIDANTS
Kenya • 31 March 2017

We might want to drink a tea for its flavor qualities, but at the same time we can be aware of its benefits and in particular its polyphenol content.
One of the varieties with the most antioxidants is TRFK 306/1. It was developed by the well-known Tea Research Foundation of Kenya (TRFK), which I have visited. What's special about this variety, in addition to its polyphenol content, which is one and a half times higher than other teas, is the color of its leaves. On the right you can see their lovely purple hue.

TASTING AND
CONTEMPLATING

Nepal • 28 August 2015

The advantage of photographing a window is that you can layer two images: here, the tasting set being prepared, and the landscape reflected in the glass. It's fun to combine and merge the two views. The tasting becomes more meaningful this way: we drink the tea, which comes from nature, surrounded by the land from which it originated.

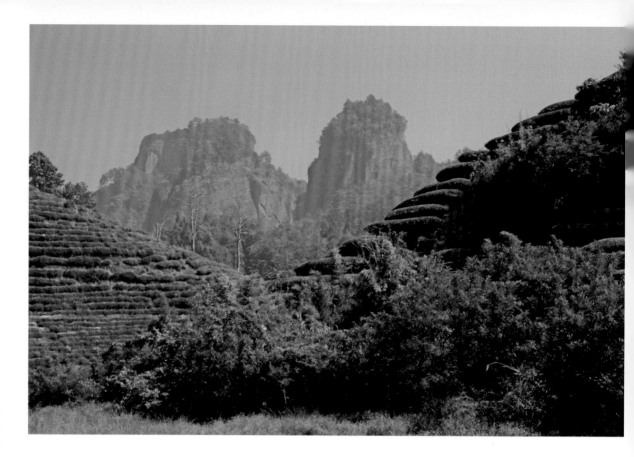

In China there's a well-known group of teas called "rock teas." These semi-oxidized teas come from Wu Yi Shan, a mountain range in the north of Fujian province. The best known is Da Hong Pao. You have to taste it at least once in your life to realize what an exceptional tea it is. It has a rare strength and length in the mouth yet remains subtle. It's fruity, toasted, woody, and sweet at the same time.

DA HONG PAO, A LEGENDARY OOLONG
China • 24 October 2014

KNOWING HOW TO APPRECIATE BITTERNESS

India • 22 August 2018

Bitterness is the only intelligent flavor, the French chef Olivier Roellinger told me as we tasted a selection of teas together, when I warned him that some Darjeelings have a touch of bitterness. It's a flavor that, unlike sweetness, needs managing and handling with care. It can be off-putting, but when we know how to appreciate bitterness, it offers such richness, such delight! Olivier Roellinger talked to me about delicious Italian food, a fine example of a bitter cuisine.

HOW TO STAY WARM WITH TEA

India • 7 February 2012

With this cold winter, you need to keep warm. Always have to hand a kettle filled with fresh water, perhaps a singing kettle whose song warms the soul and lifts the spirits. A song calling you for tea.

In India, you see tea vendors everywhere, in the streets and on the roadsides. With a kettle purring over what are sometimes simple wood fires, they're always busy. On the roads in the Himalayas, they might set up stall on the corner of a rock. You squat down next to the vendor and take your time sipping the scalding blend of tea, milk, and spices. You simply take time to do yourself some good.

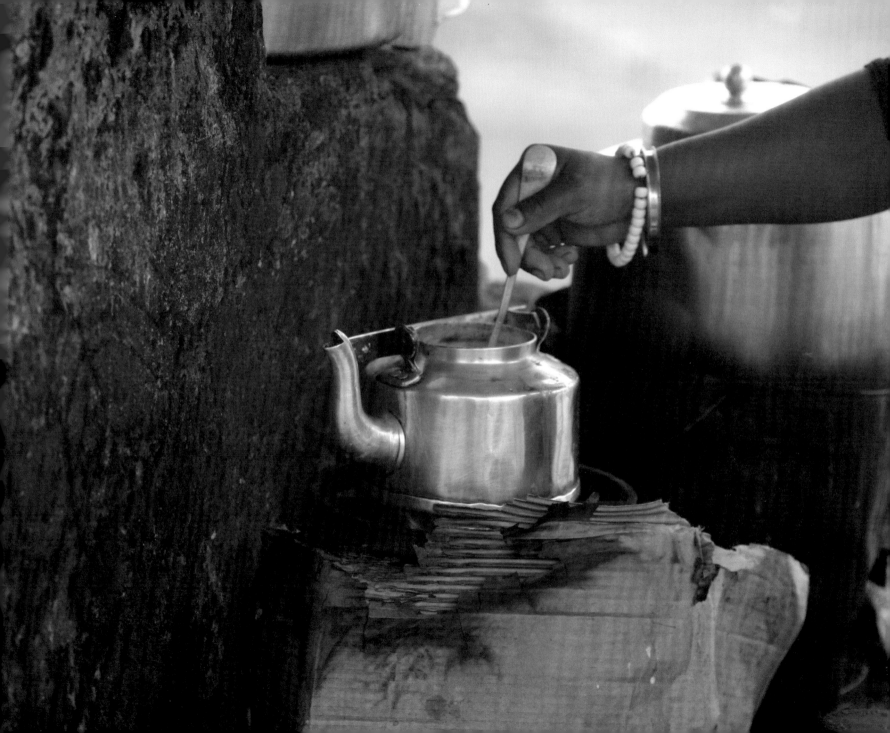

Instinctively, this photo makes me happy, because in Asia I discovered the pleasure of drinking tea in the evening and even at night. In some Western countries many people are reluctant to drink tea after five o'clock, but in China people enjoy it at any time, even very late.
Sometimes, your cup is bathed in the warm reflections of the neon lights.

EVENING TEA IN CHINA
China • 16 August 2013

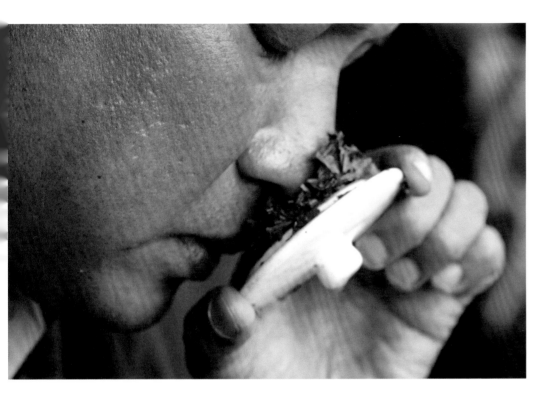

TO HAVE A NOSE FOR TEA

India • 3 August 2010

When you taste tea, you start by smelling it. This is a very important stage in the tasting process. You look at the infused leaves and inhale their aroma, and in doing so you can learn a lot about the tea. For example, you could easily detect problems such as over-drying, an overly long oxidation process if it's black tea, or inappropriate fermentation. Of course, it also allows you to identify the qualities of the tea and the different aromas you might find again in the cup in more or less similar forms. It's only after smelling the infused leaves (what's known as the "infusion" in the trade) that we actually taste the liquid itself.

Here, in Badamtam (Darjeeling), Binod Gurung has closed his eyes. His nose is plunged into the damp, warm leaves. He inhales and analyzes, all in a state of total concentration.

TEA MAKES US
FEEL ALIVE

Myanmar • 19 July 2013

When I visit a monastery in Asia, I always think of the important role the monks played in the spread of tea. Because tea has the ability to keep the mind alert, because it helps us to learn and assimilate knowledge, its use spread from monastery to monastery, from China to Korea, then from China to Japan.

What the monks told us by carrying tea across borders in this way is that tea makes us feel alive. It's good for our body and good for our soul.

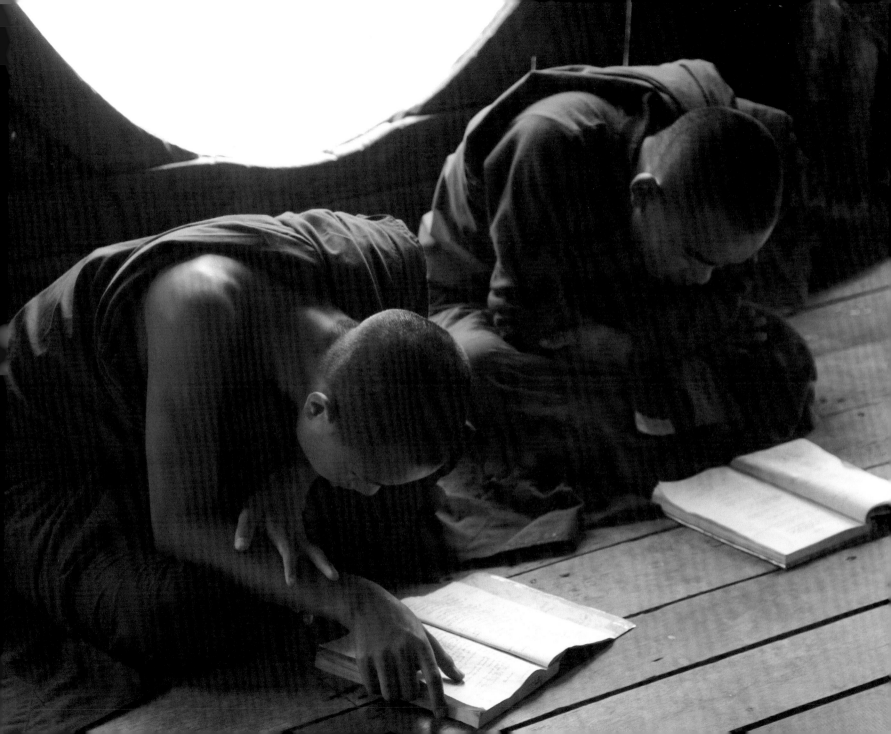

ONE HUNDRED TEAS
A DAY

India • 12 March 2013

At the moment I'm tasting between fifty and a hundred different teas a day.

I try them in series of about ten or twelve. When you taste so many teas at the same time, you spit them out, for obvious reasons. Most importantly, you taste each tea twice, and in a different order, so you're not influenced by the qualities or flaws of the previous tea.

This is because when you taste several batches in a row, you have a tendency to pick out what's different about them rather than their similarities, and if I didn't taste each one twice, I could miss out on some wonderful teas.

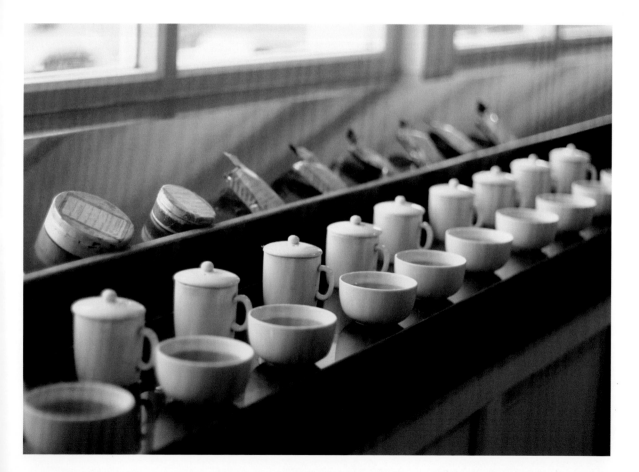

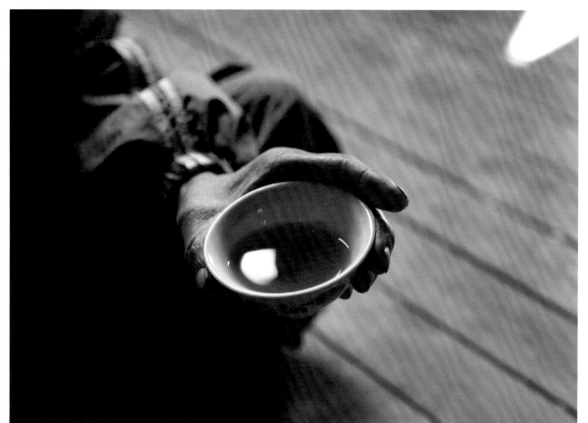

THIS FLAVORED WATER
IS GOOD FOR US
Myanmar • 1 February 2013

I like this hand holding a cup of tea.
A simple cup of tea. I like the way
the cup is an extension of the hand.
The cup and hand are as one, they
know each other, they're made for each other. They're
joined together. Tea is nothing more than that. Tea is
nothing more than flavored water that sustains you and
does you good. It's always there for you, a simple pleasure
to be savored in every moment.

"WHY DO YOU DRINK TEA?"

Myanmar • 5 March 2013

In a recent interview, a journalist asked me why I drink tea. I drink tea to relax, to find a moment's peace, to create some space for myself. I drink tea to stay calm, to give myself a break, to do myself good. I drink tea in the same way that others practice yoga, to keep myself feeling good, to replenish. I also drink tea for the pleasure of preparing it and the pleasure of serving it to others. I drink tea for the happiness that comes from sharing it.

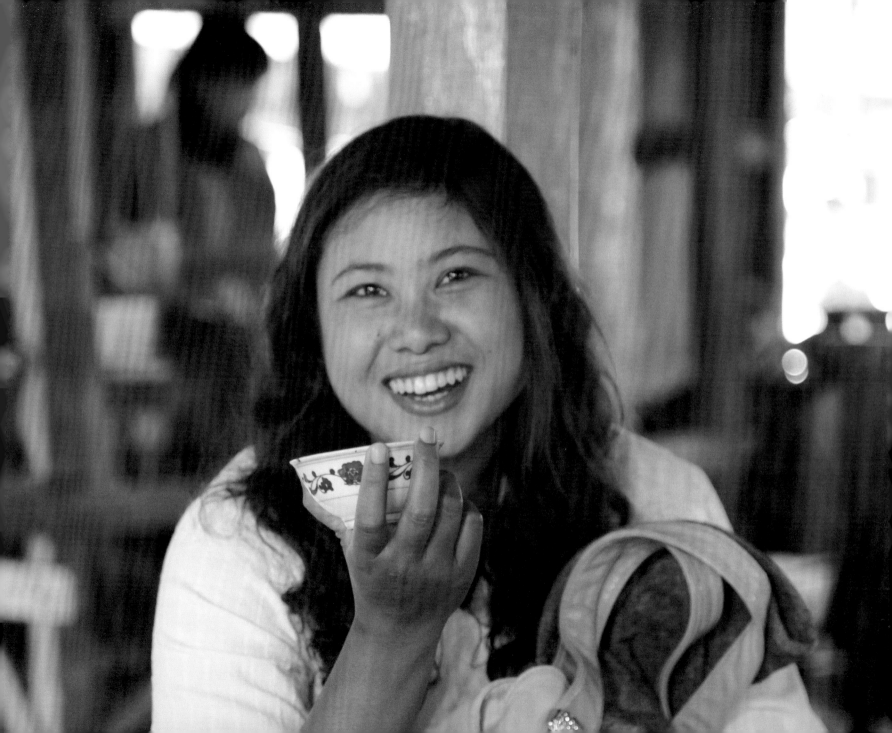

AN ENLIGHTENED
ROOIBOS TASTING
South Africa • 22 February 2013

There are different grades of Rooibos, but not much difference between them. However, the "long cut" offers the most interesting experience in terms of fine flavors and powerful aromas. It's the most harmonious. It's the only grade I've bought for years.

🍃 *An interesting detail: for Rooibos tastings in South Africa, the cups are lit from beneath in order to judge the clarity of the liquid.*

On the Amgoorie Tea Estate, tea is tasted both with and without milk. This is because some of the tea produced by this plantation is particularly full-bodied and is appreciated by British buyers. By lightening each cup with a cloud of milk, we're tasting the tea in the same way as the customer.

🍃 *While adding milk is sacrilege for the finest teas, it's natural for more powerful brews. The milk reduces the astringency and bitterness.*

WITH OR WITHOUT MILK?
India • 28 June 2011

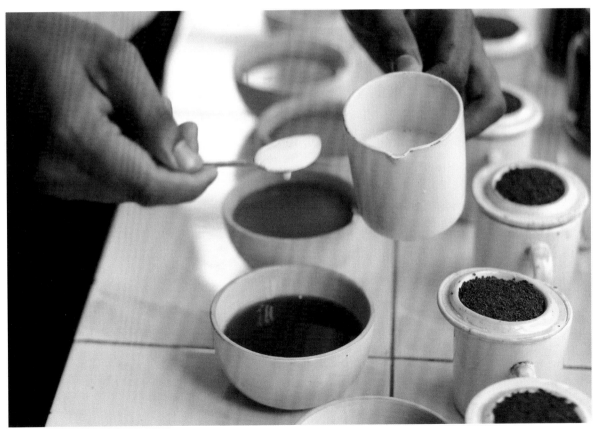

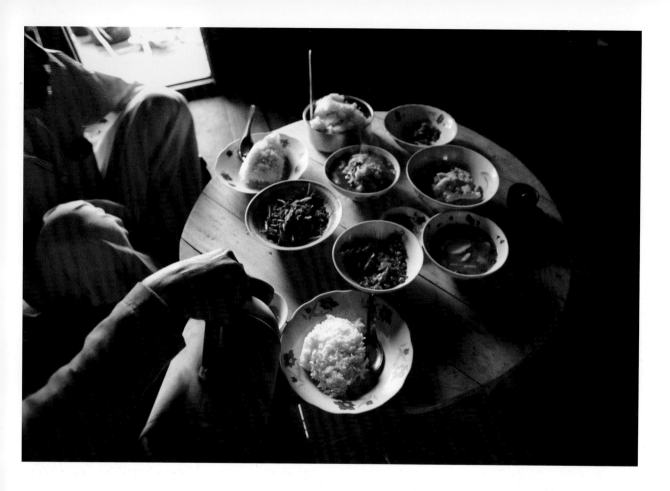

A DIFFERENT WAY
OF ENJOYING TEA

Myanmar • 25 January 2013

In some countries, people don't just drink tea, they eat it. In Myanmar, they ferment tea leaves in bamboo tubes before serving them drizzled with sesame oil. This dish is presented as part of a meal, but it can also be offered at the end of some family and religious ceremonies.

When you make yourself a cup of tea, you naturally don't need to measure out the leaves to the nearest milligram. It's not the same for me. At each comparative tasting, the tea must be weighed with the utmost precision, otherwise I can't assess each liquid properly.

MEASURING TEA CAREFULLY
India • 27 November 2012

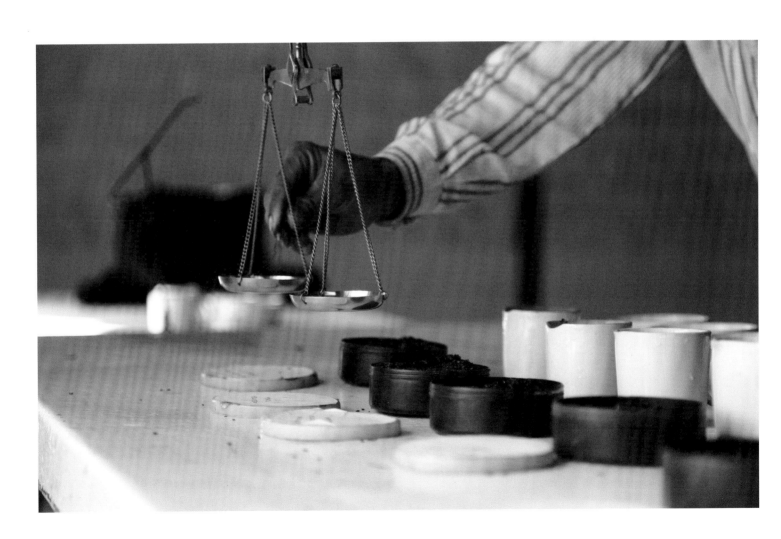

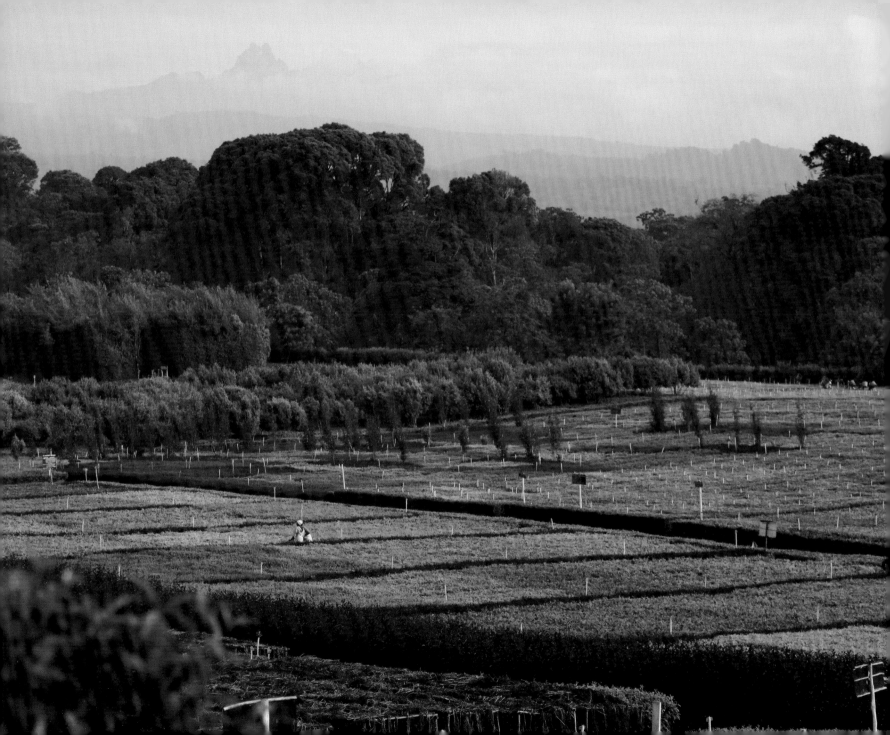

A PREMIUM TEA
FROM KENYA

Kenya • 25 March 2016

In my teapot this morning, a portion of Mount Kenya Golden Leaves is opening up in the water. This is the first premium tea I've found in Kenya, and it has just arrived. I love its notes of honey, wood, wax, and licorice. They're warming and celebrate the end of winter in their own way. They make you want to stay indoors a little longer, warm and cosy. They make you want to breathe in their aromas, cupping the bowl in both hands.

A premium tea from Kenya is a big deal. The country is the world's third biggest tea producer, and the biggest exporter. Almost all the tea it produces is "dust," destined for tea bags. So we should encourage those who are working hard to make quality teas, who pick the leaves by hand with care, doing things the traditional, artisanal way, rather than on an industrial scale.

This photo shows the Kangaita research center, which provides valuable support for small producers.

CONCENTRATING ON THE AROMAS AND FLAVORS OF TEA

India • 20 November 2012

Tea-tasting requires nothing more than a table, fresh water heated to the correct temperature, an attentive assistant, and good light. A peaceful place like this one helps you concentrate on the essentials: the tea's aromas and flavors.

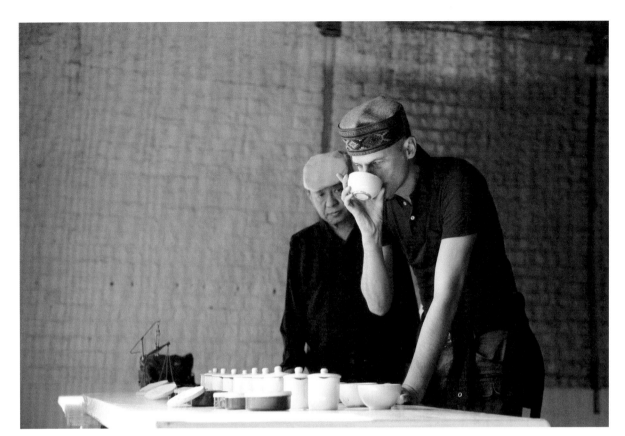

IN DHARAMSALA
India • 13 November 2012

A tasting session at the Manjhee
Valley Tea Estate in the company
of its manager, Chettaranjan Rai. The Manjhee Valley Tea
Estate is in Dharamsala and produces some of the best
teas in the region. Before this, Chettaranjan worked for
more than ten years on tea plantations in Darjeeling and
is extremely experienced. Here, he's watching me closely,
waiting to see what I think of his tea.

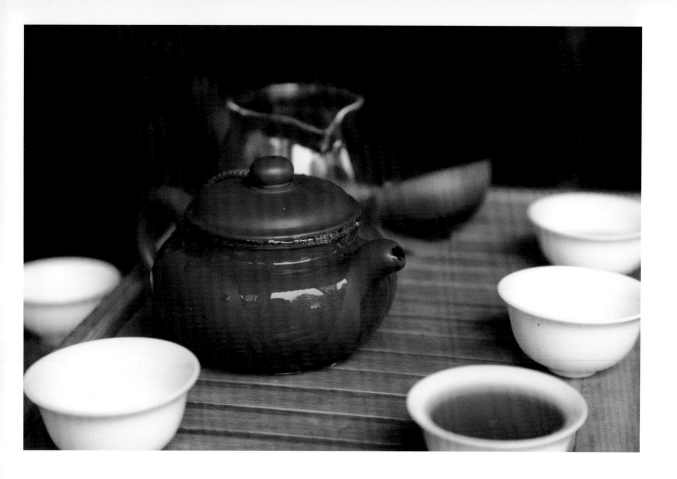

A GOOD REASON
TO USE A TEA BOAT

China • 28 August 2012

When you make tea using the Gong Fu method, you fill your teapot right to the top, even letting the water spill over to get rid of the scum. Hence the use of the tea boat, on which the teapot is placed here, which serves as a receptacle.

INFUSING DIRECTLY
IN THE GLASS
China • 11 May 2012

In China, tea is often infused directly in the glass. As you drink your *cha*, your host tops it up with hot water. To prevent the leaves from going in your mouth, you bring your teeth together, which doesn't stop you smiling at the same time.

TASTING

DIFFERENT
DRINKING HABITS

Myanmar • 26 July 2013

When it comes to tea drinking, customs change from country to country. In Myanmar, for example, tea is served slightly diluted with sweetened condensed milk. You can like or not like this way of doing things, but one of the many qualities of *Camellia sinensis* is its tolerance and its ability to make the people of our planet want to adapt it to their own taste.

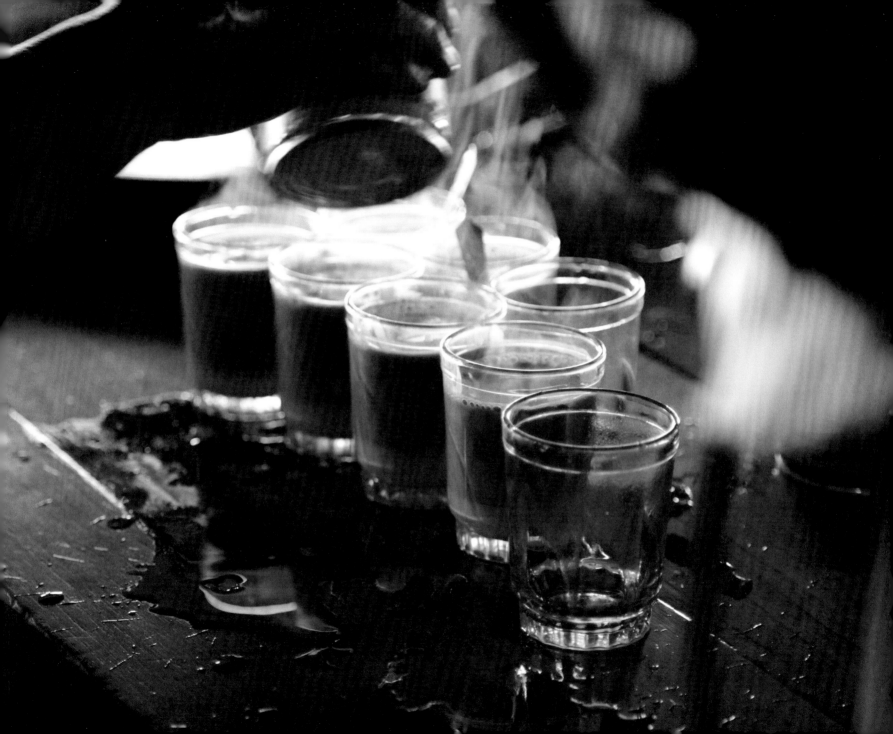

NEW SAMPLES

India • 20 March 2012

For the past two days, samples of tea have been delivered to my tasting room in large numbers. As soon as they arrive, I taste the contents of the little bags on which are marked the name of the garden, the batch number, the grade and the quantity of tea produced.

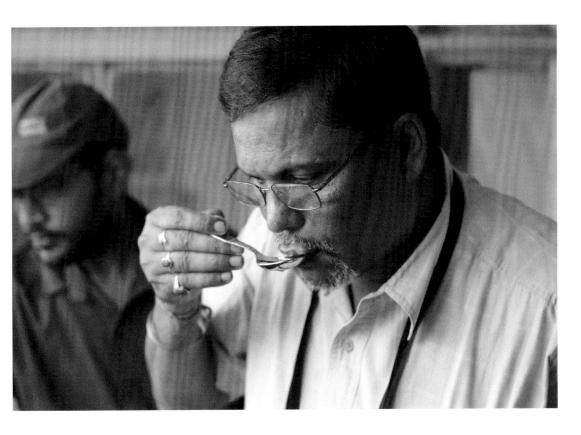

LIKE A GOOD WINE

India • 16 December 2011

Tasting tea is a bit like tasting wine. You take some of the liquid in your mouth and swirl it around gently. Then comes what we call "retro-olfaction": you exhale air through your nose, directing the aromas toward your olfactory bulb. With your head slightly lowered, your cheeks sucked in, you hold the liquid around your tongue and inhale through your mouth several times. By exhaling this air out through your nose, you increase your olfactory capacity to its maximum. We use this method to enhance our assessment of a tea. It's necessary when you want to describe a tea's aromatic profile, for example.

Here, with one of his assistants, is my friend Anil Jha in action. His Turzum and Sungma teas have acquired an excellent reputation.

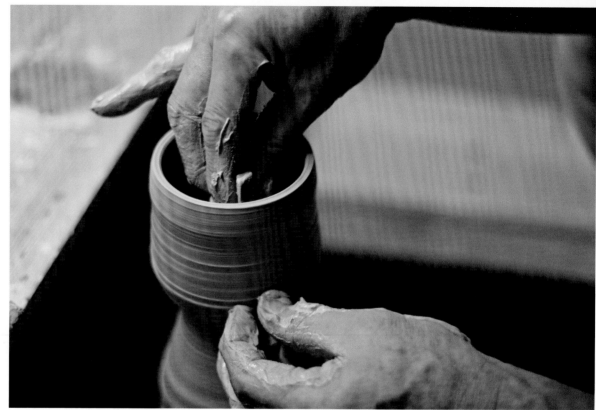

RAKU

Japan • 8 February 2011

Each tea accessory used during the *Cha No Yu* (the Japanese tea ceremony) is made using the methods of an ancient craft. Raku is a classic technique often used to make the *chawan*, the bowl used in the tea ceremony. This process involves firing at a very low temperature.

Here, in Hattori Koji-San's Kyoto studio, I watched the master potter deftly work the clay and gradually shape the contours of a tea bowl.

GONG FU CHA

China • 7 January 2011

In the West, tea is often prepared in a teapot, usually con-
taining between 1 and 3 pints (50cl and 150cl) of tea. In Asia,
however, where tea is very popular, the use of a teapot of this
size, or even of any teapot, is not as common as here. In China,
for example, which undoubtedly has the most tea drinkers, it's
traditionally drunk from a *zhong* (a small bowl with a lid) or from
tiny cups filled from a tiny teapot.
These utensils—some of which you
can see in this photo—comprise
what is called the Gong Fu Cha.

A SPECIAL MOMENT

Tea-tasting is a special moment for me. While we wait for the teas to steep, we talk, or we look at the dry leaves. Then, when the tea is ready, we exchange cups, without a sound. We inhale the aromas of the leaves, look at the liquid, and taste it. Then we compare it with the cup beside it. It's a moment of pleasure and concentration. Hand movements are precise and slow. To me, this serenity is important in order to appreciate all the delights offered by a cup of tea.

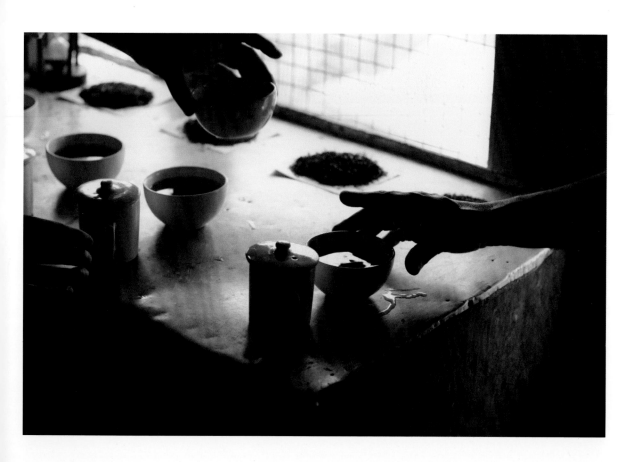

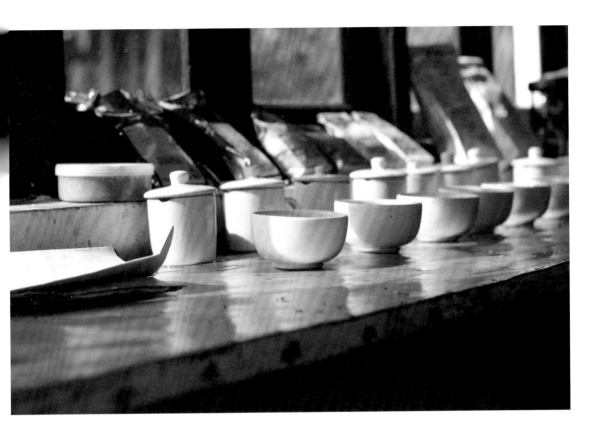

WINDOWS TO LET IN THE LIGHT

India • 6 September 2011

When tasting tea, it's good to have a source of natural light in which to judge the leaves and the infusion, as well as the liquid. It means you can assess the tea not just on its taste and aroma, but also on its appearance.

That's why, on most plantations, the tasting room has windows right along one side, to let in plenty of sunlight. The cups of tea are placed along the windows, and while the tea is infusing, I can spread the dry leaves on a card in order to get a good look at them and judge the quality of the plucking. Or, while waiting for the timer to tell me when the infusion is ready, I can take my camera, as I did here in Darjeeling, and find the best angle to immortalize this beautiful morning light.

THE FRENZIED PACE
OF THE SPRING HARVESTS

My selection of first-flush Darjeelings is over, the Nepalese season is in full flow, and then it's the turn of the new-season China teas, before the first Japanese Ichibanchas are ready. Between 1 March and 10 May every year, I can taste more than a hundred teas every day, not counting the ones I infuse several times when I'm choosing between different batches. This enjoyable activity, which I always look forward to, peaks around the end of April. At this time of year, so many samples pile up every morning in the packages sent by express mail from Nepal, India, China, and Japan, that I sometimes don't know which saint to turn to.

TASTING

There are many teas to taste at this time of year. For the next few months, I'll be tasting dozens of teas every day, up to a hundred or a hundred and fifty at times. I taste them "blind" because I don't want to be influenced by my friendship with particular farmers. The name of the garden is hidden so that the initial selection is based solely on a sensory analysis. To express my preference, I make this gesture, shared by many planters: I push the cup gently with my fingertips, palm facing upward.

AT MY FINGERTIPS
Nepal • 20 March 2015

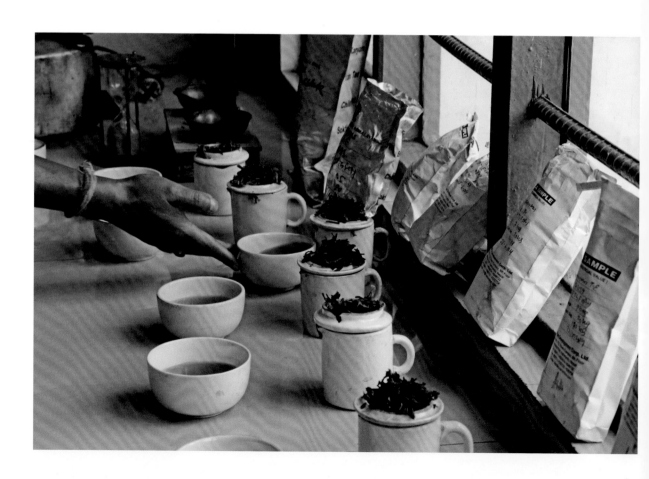

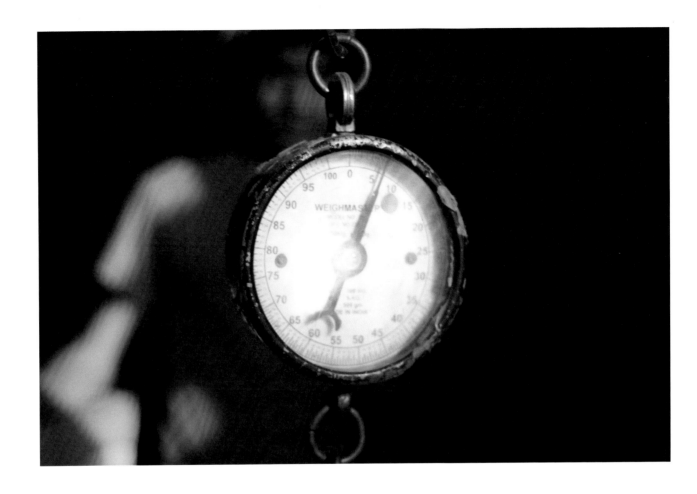

Making tea requires great precision. Scales are used to weigh the leaves, then there's a kettle with volume markings, sometimes a thermometer, and a timer. When I'm on a tea plantation, I like to photograph the different measuring instruments I see, like here, in Nepal.

A PRECISE AFFAIR

Nepal • 25 April 2014

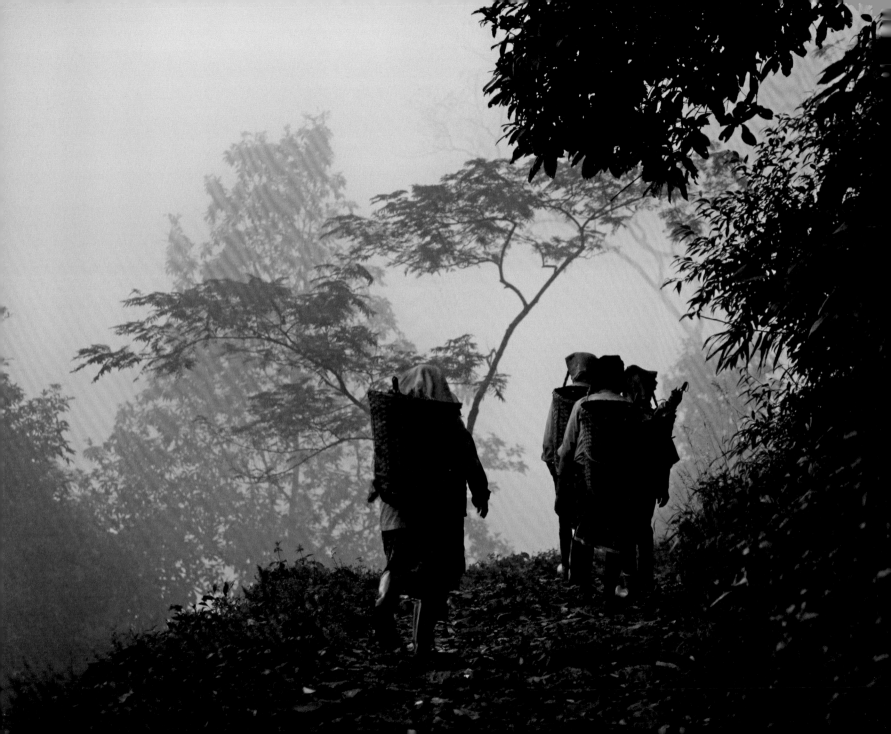

Thanks to...

Bénédicte Bortoli, who had the idea and the energy
to turn my blog into a book,

Bénédicte, Chloé, Hélène, Alexandre, Laurent,
and Mathias, for their precious help,

Marta, for the quality of her translations,

Elle Maillart and Nicolas Bouvier, who inspired me,

Léo, my assistant tea researcher.

And I'd like to wish the tea sommeliers a long
and satisfying career.

PUBLISHING
Bénédicte Bortoli

GRAPHIC DESIGN AND ARTWORK
Prototype

TRANSLATION FROM FRENCH
Marta Scott

PROOFREADING
Nicole Foster

PHOTO CREDITS
François-Xavier Delmas. Except: Christine Delétrée, p. 4, 168, 189;
Alexandre Denni, p. 9; Alexis Berger, p. 30; Anaïs Barth, p. 80.

Copyright ©2020, Éditions de La Martinière,
an imprint of EDLM for the original and English translation
ISBN: 978-1-4197-5181-3
Legal deposit: April 2020

10 9 8 7 6 5 4 3 2 1

PHOTOENGRAVING
Quadrilaser

Printed and bound in April 2020 in Spain by GraphyCems

Abrams books are available at special discounts when purchased in quantity
for premiums and promotions as well as fundraising or educational
use. Special editions can also be created to specification. For details,
contact specialsales@abramsbooks.com or the address below.

Abrams® is a registered trademark of Harry N. Abrams, Inc.

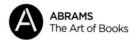

ABRAMS
The Art of Books

195 Broadway
New York, NY 10007
abramsbooks.com

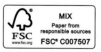

MIX
Paper from
responsible sources
FSC® C007507